A SEASIDE ALBUM

Photographs and Memory

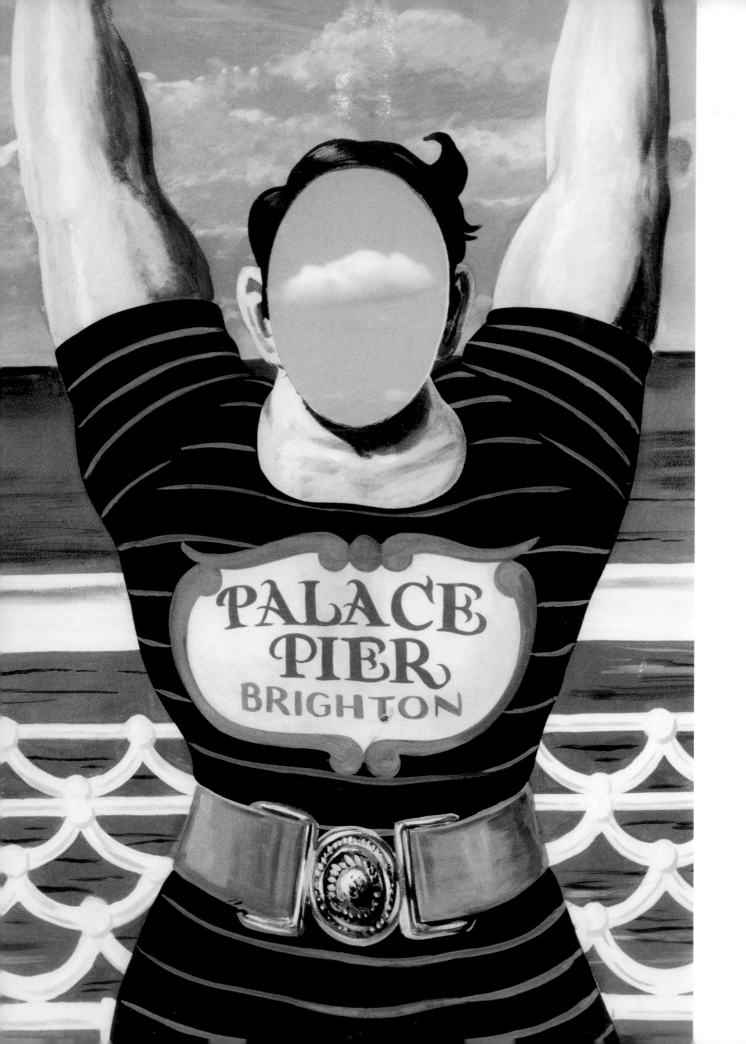

PHILIPPE GARNER

A SEASIDE ALBUM
Photographs and Memory

Brighton & Hove

The Royal Pavilion, Libraries & Museums, Brighton & Hove

in association with

Philip Wilson Publishers

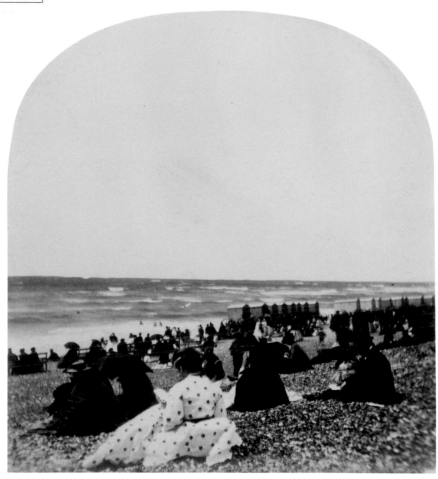

Unknown photographer, figures on the beach, 1860s, albumen print,
probably one of a stereoscopic pair, *88 x 82mm*

Frontispiece: **Philippe Garner**, painted panel with cut-out on the Palace Pier,
28 August 1995, 11.35am, silver print, *image 560 x 465mm*
Such 'folk art' panels were designed for visitors who would show their heads through
the cut-out to pose for a souvenir photograph

Overleaf: **Attributed to John Barrow**, the Palace Pier Theatre, summer 1958,
on or before 2 July, silver print, *140 x 242mm*
Taken on behalf of James S. Gray for his regular feature on the changing face of the town
in the *Brighton & Hove Herald*

CONTENTS

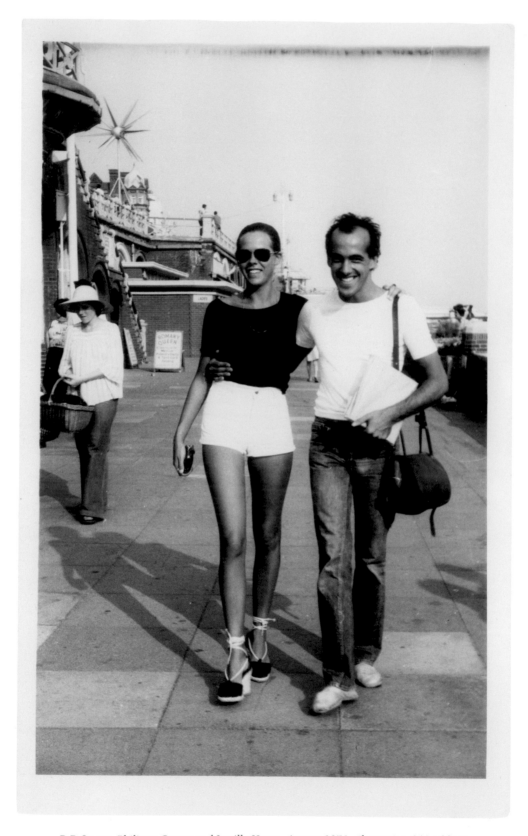

R.P. Stuart, Philippe Garner and Lucilla Hume, August 1976, silver print, *144 x 90mm*

TALISMANS

It is late afternoon on a sunny day in August, in 1976. A young couple are walking along the lower promenade at Brighton. He is twenty-seven. She will be twenty-one in a month's time. They both live in London, but first met in Brighton the previous year and return regularly at weekends. Each with an arm around the other, they progress casually along the under-walk. Some distance behind them is the Palace Pier. To their right, on the upper promenade, people stroll along the pavement and traffic makes its way along the King's Road, passing the bright white stucco and black cast-iron trimmed facade of the Grand Hotel. Holidaymakers, and locals with the time to spare, enjoy the sun on the deep pebble beach and look out across the Channel between the Palace Pier and the West Pier some way off in the distance, towards Hove. It has been an exceptional summer of almost unbroken sunshine.

The scene is in many ways unchanged since a century before. Then, more formally dressed figures would similarly take the air on beach and promenade. In the distance to the east was the old Chain Pier, and from the roadway came the sounds of horse-drawn carriages, and dust from the dry surface. A commentator, writing in 1863 of a series of studies of the promenade and beach by photographer Valentine Blanchard, describes the town in July as 'hot and dusty – blazing with unmitigated sunshine'. The photographer has preferred on this occasion to work with the 'bright skies, fresh air' of the fashionable later season. In one image our commentator observes 'several hundreds of people, mostly walking, a few standing or sitting…some carriages in motion, many at rest, including a little goat-chaise and a wagonette drawn by a donkey, the boy in charge of the last-named vehicle gazing fixedly at Mr Blanchard's operations'. He draws our attention to the Grand, 'the new monster hotel', and to 'a few fleecy clouds [that] break up the monotony of the sky'.[1]

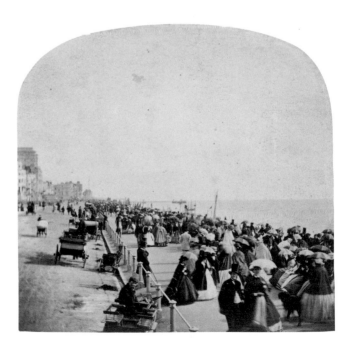

Valentine Blanchard, 'A Morning Promenade…', 1863, albumen print, one of a stereoscopic pair

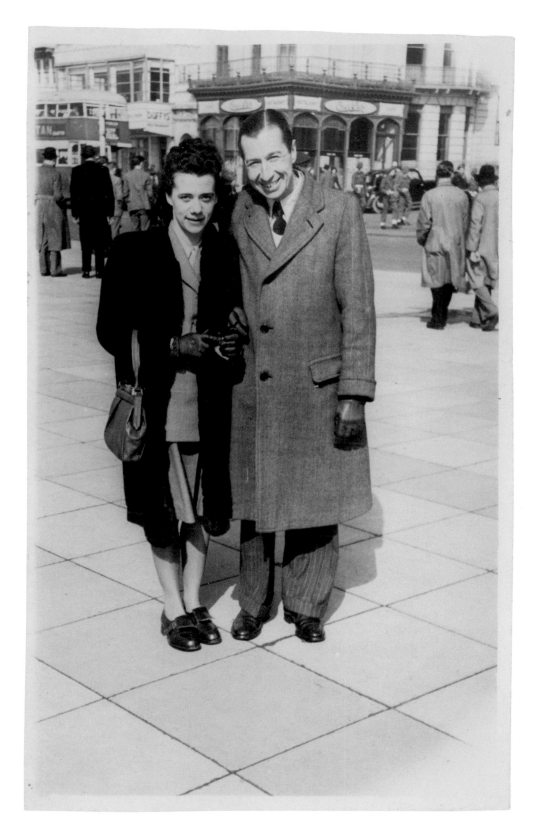

Unknown photographer, Albert and Angèle Garner, 23 March 1947, silver print, *133 x 83mm*

The young couple attract the attention of a professional beach photographer, one of those opportunist operators who have been plying their seasonal trade since the 1850s, armed with the rudiments of photographic skill and with the easy charm to entice punters into purchasing a memento of a summer stroll. Mr R.P. Stuart, for that was the gentleman's name, had made his way earlier in the day from his base in Stirling Place, Hove, to take up his position. He had set up a promotional panel with sample prints, just along from the Romany Queen's fortune-telling booth, and he no doubt anticipated good business under a promising clear blue sky. The young man has more than a passing interest in photography and is easily tempted by Mr Stuart. The girl is happy to be photographed. A couple of pictures are taken, one full-length of the couple walking, the other half-figure. Money is paid over, £1 for the two, name and address written down for the despatch of the prints, which arrive a few days later. They are consigned with care to a place of safekeeping, the magical talismans of an unrepeatable moment.

Some thirty years previously, another couple had similarly stopped for a photographer. Smartly dressed in overcoats and gloves against a fresh morning breeze, they had been walking along the pavement by the West Pier, not so far from their modest rented accommodation in the town centre. The war was still too close a memory, but the promenade and beaches had been fully restored to use, barbed wire barriers had been removed, the piers re-opened, and life was returning to normality. Much pride was to be taken locally in the 3rd October 1947 visit of Winston Churchill. The great wartime Prime Minister inspected a guard of honour of the Royal Sussex Regiment in the Pavilion grounds and received the Freedom of the Borough from the Mayor, Alderman T.E. Morris.

The gentleman was from an old Sussex country family – his father had been head lad in a racing stables at Pyecombe. He had served in the RAF during the war, stationed first in North Africa and then in the South of France. It was during a posting in Aix-en-Provence that he had met and married the young Corsican woman

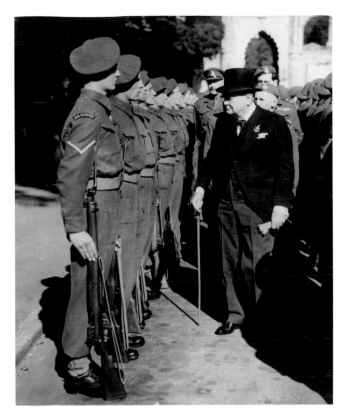

Planet News Ltd, 'Mr Winston Churchill receives freedom of Brighton', 3 October 1947, silver print, *253 x 204mm*

who now stood beside him as they posed, arm in arm, for an unnamed photographer. Their delicately balanced mood of hope tinged with uncertainty was recorded forever as they set out to make their life together in Brighton. In these first years after the war, in the peace won under Churchill's guidance, they conceived a family. Their first child, a girl, was born on the 1st January 1948; their second, a son, was born on the 6th March 1949. When, many years later, the children shared the family's personal photographs, it was their son who preserved the single print of that promenade snapshot of his parents. He knew he must keep it safe, guarding it as a significant link with the past, a key to the puzzle of his own life.

1. 'Stereographs, Instantaneous sea and land views at Brighton: Photographed by Valentine Blanchard. London: C.E. Elliott, Aldermanbury Postern', *The British Journal of Photography*, 1 January 1864, p. 18

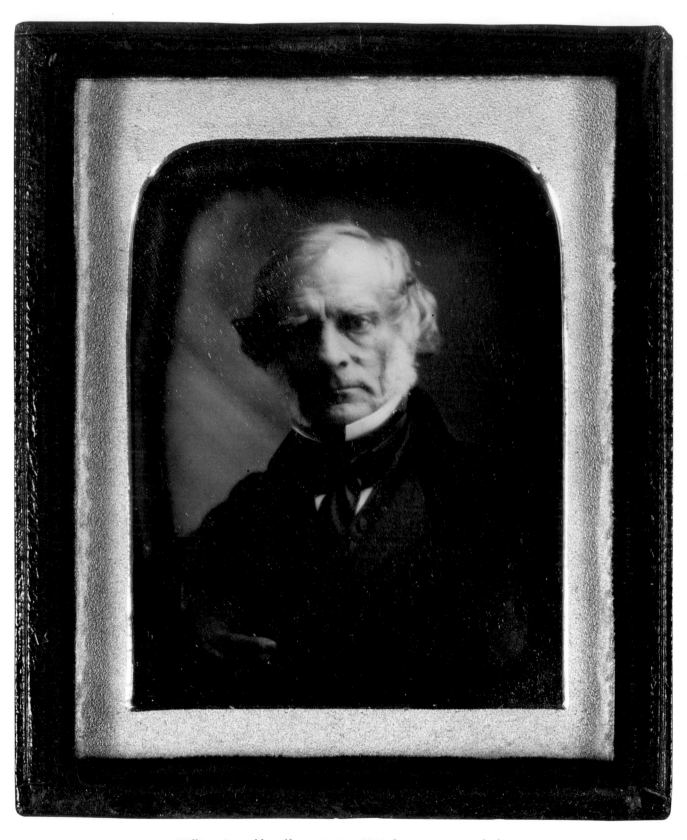

William Constable, self portrait, circa 1845, daguerreotype, *ninth plate*

DAWN OF THE ERA
OF THE PHOTOGRAPH

A hedonist, self-indulgent and extravagant, yet inspired, ambitious and imaginative, George Augustus Frederick, Prince of Wales, destined to become Prince Regent, then monarch as George IV in 1820, did more than anyone to transform the destiny of the small, quiet fishing village of Brighthelmstone. A modest cluster of houses and commercial premises on the Sussex coast due south of London was transformed into the Royal spa town of Brighton. The lasting legacy of George's vision was the construction of grand, elegant neo-classical terraces, squares and individual houses, and the dramatic elaboration of the farmhouse that he had first leased in October 1786 into the full-blown, exotic, orientalist fantasy that is the Royal Pavilion. Architects John Nash, Charles Augustus Busby, and father and son, Amon and Amon Henry Wilds, gave to Brighton handsome buildings and grand vistas on a scale that evoked direct comparison with the capital. The town became a fashionable resort, flourishing during the Regency and beyond.

The Pavilion was effectively completed in 1822. In the same year, an ambitious marine engineering project was undertaken, the construction of a long suspension pier, the Chain Pier, to provide a recreational walkway out to sea and to serve as a landing stage for sail vessels. The advent of rail connections gave a further key impetus to the town's growth. The arrival of the age of steam rail travel coincided for Brighton with the announcement of the invention of viable photographic processes. On the 4th February 1839, the first permanent rail of the London and Brighton line was laid, at Hassocks Gate. This was the year in which William Henry Fox Talbot in London and Louis Jacques Mandé Daguerre in Paris published their historic discoveries of techniques for fixing images made by the action of light. On the 12th July 1841, the Brighton line was opened as far as Haywards Heath, with a direct connection to London. Later that year, the first photographic studio was opened in Brighton. The town could herald the dawn of a new epoch – the age of mobility and the era of the photograph.

On the 14th November 1841, a gentleman sat down at his table in the quiet of one of the grand rooms of 57 Marine Parade to pen a letter to his beloved sister, Susanna. He was fifty-eight years old, slim, with strongly chiselled features and grizzly white side-whiskers, elegantly dressed, characteristically in long, dark frock coat and waistcoat and slender, tapered trousers, his head held erect above a high stiff collar and cravat. William Constable had reason to feel satisfied as he wrote 'I opened my concern of business last Monday, – for the first day or two I took very little money indeed...I could not help feeling anxious and nervous, although the result was what I reasonably ought to have expected – but I feel that every day I am growing in notice and have no doubt that I am gaining a very fast and respectable foothold here.... I am crowded with visitors all day – from 11 to 4...there is nothing against me but the lateness of the season.'

Constable had opened his Photographic Institution on the 8th November. He had been fascinated by the news of Daguerre's process and saw the potential to open a portrait studio exploiting the extraordinary clarity of the unique images on sensitised silvered copper plates that the Frenchman had proposed. The Institution was one of the very first studios opened beyond the capital. In front of his four-storey house, situated on the eastern sea front facing the Chain Pier, he had constructed 'a room...of which the roof and front consisted of plate glass in an unfinished state, so as to decompose the prismatic rays of light, admitting only the blue tint'.[1] He could later boast in a printed advertising broadsheet [2] that his premises were 'most favourably situated with respect to quantity and purity of light'. His venture was also well placed to capitalise on the clientele associated with a Royal resort. For although Victoria did not share George IV's fondness for Brighton, the court connections had established a prestigious potential market. Constable's reputation was consolidated by recommendation. 'The persons who have been once,' he wrote, 'come again and bring their friends.... I have carriages standing at my door half the day – sometimes 3 at a time.'[3]

By 1848 he was able to confirm: 'I have had many sitters from the ranks that are called noble...viz Vic't Jocelyn and his wife – Duke of Montrose and his wife – several ladies of the Russell (Bedford) family – Lady Kerrison – Marquess of Abercorn and his wife – Duke of Devonsh[ire]. [The so-called 'bachelor' Duke] with no wife....'[4]

William Constable's letter to Susanna extends an invitation to join him with her son, Clair James. Her journal records an extended stay from late November and, as well as noting evocative details of life in the Constable household and of activities in the studio, provides a vivid sketch of life in Brighton. On the 17th February, for example, she writes 'The Queen on the Pier soon after ten o'clock and in the afternoon driven past here by Albert in a phaeton and pair attended by outriders and two carriages and four. The Marine Parade was thronged with carriages and pedestrians.'[5] Susanna's journal well evokes everyday events – frequent long walks with her son and their dog Mobsby; the gift of 'two pineapples...also three tickets for the Queen's Chapel in the Palace';[6] and of course the weather, all too often dull and rainy. She also records the visits of eminent sitters, most notably those of Prince Albert himself.[7]

William Constable enjoyed a decade of exclusive professional practise in the town. As with many of the medium's pioneers, his concerns were as much scientific and artistic as commercial, and his surviving correspondence testifies to the constant curiosity that had marked his earlier varied career as retailer, miller, traveller, artist, surveyor and engineer. He enjoyed the visits of other photographers, including Antoine Claudet from London and Richard Dykes Alexander of Ipswich. Leone Glukman, the Dublin daguerreotypist, was a good friend and regular correspondent. Constable was keen to refine his skills and techniques, enquiring after new procedures and equipment. He visited Richard Beard's London establishment in October 1845, and in 1846 proposed a journey to Paris, where he knew of 'two principal makers of lenses...Chevalier and Lerebours'.[8]

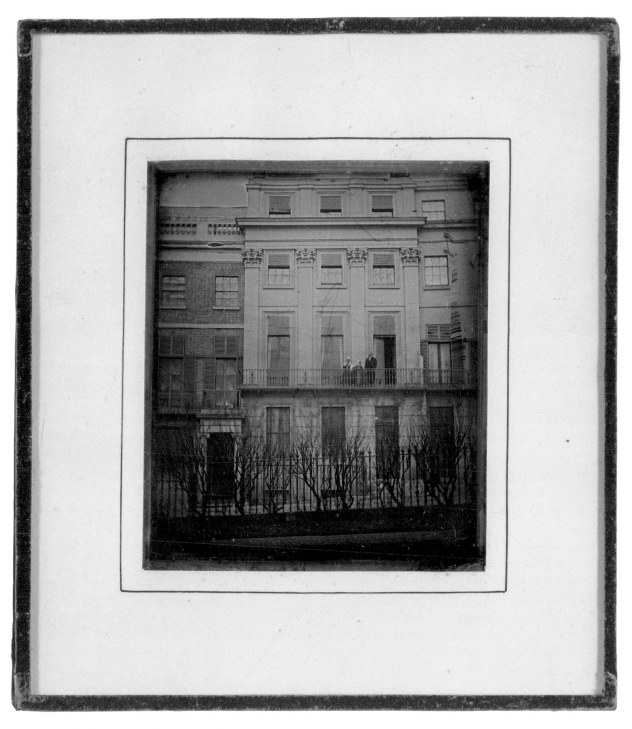

Attributed to William Constable, 10 Lewes Crescent, with group including Richard Dykes Alexander
on the balcony, probably June 1846 or soon after, daguerreotype, *sixth plate*
A companion daguerreotype is on a plate bearing the mark of the optician and plate-maker
Lerebours of Paris, most likely purchased by Constable on his trip to Paris in June 1846

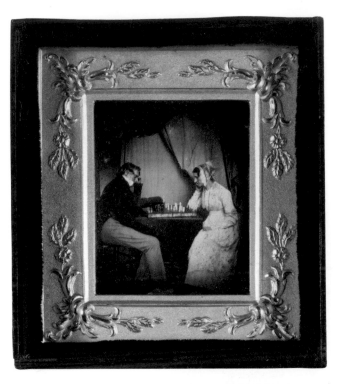

William Constable, group of the photographer and his sister Susanna playing chess, circa 1845, daguerreotype, *ninth plate*

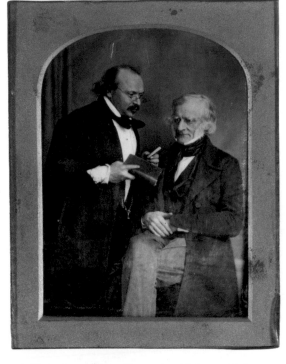

William Constable, self portrait with Leone Glukman, circa 1845, daguerreotype, *quarter plate*

Beyond their technical achievements, Constable's daguerreotypes reveal curiosity, humour and sensitivity. His legacy comprises tender and immediate portraits of friends and family, of eminent associates and unidentified visitors – an emotive gallery of faces and personalities. He poses with his sister as 'The Chess Players', enacts a curious allegory with Glukman, and sits for a picture over a lunch table with a friend. A lad sits bare legged in an oversized white shirt; a young child is set behind a cloud-like blur – like a Raphael cherub; the photographer's two nieces are linked by their embrace and by their identical dresses. Constable cherished a particular portrait of his young nephew, 'a beautiful picture of the little chap in his cloak and cap,' notes Susanna. 'It is framed and hung up in Uncle's office.'[9] Their fondness was mutual. It is to the respect and care of Clair James Grece, and in turn his heirs, that we owe the survival of a substantial number of these magical images – the indisputable data, in vapour of mercury on silvered plates, of life at 57 Marine Parade in the 1840s.

Even before Constable had set up his studio, another gentleman had become irresistibly attracted to the potential of the new photographic medium and was destined to make his particular mark on the story of photography in Brighton. Joseph Ellis, a prosperous businessman, poet, connoisseur of art and of literature, and enthusiast of both the technical and the philosophical aspects of the sciences, was depicted by a friend as 'a gentleman of the old school; his manners were punctilious, and his dress was eccentric.'[10] Ellis described himself as 'among the earliest Photographic zealots [who] as early as 1841, about two years after the first announcement of the discoveries of Talbot and Daguerre',[11] had written the first draft of an essay on the birth of photography. Born into a prosperous family in 1815, a month or so after the battle of Waterloo, he moved to Brighton in 1845. Here he became proprietor of the Bedford Hotel, 'the handsomest hotel…the resort of the noblest of the land…',[12] and worked as the senior partner in the wine and spirit merchants, Ellis, Wilson

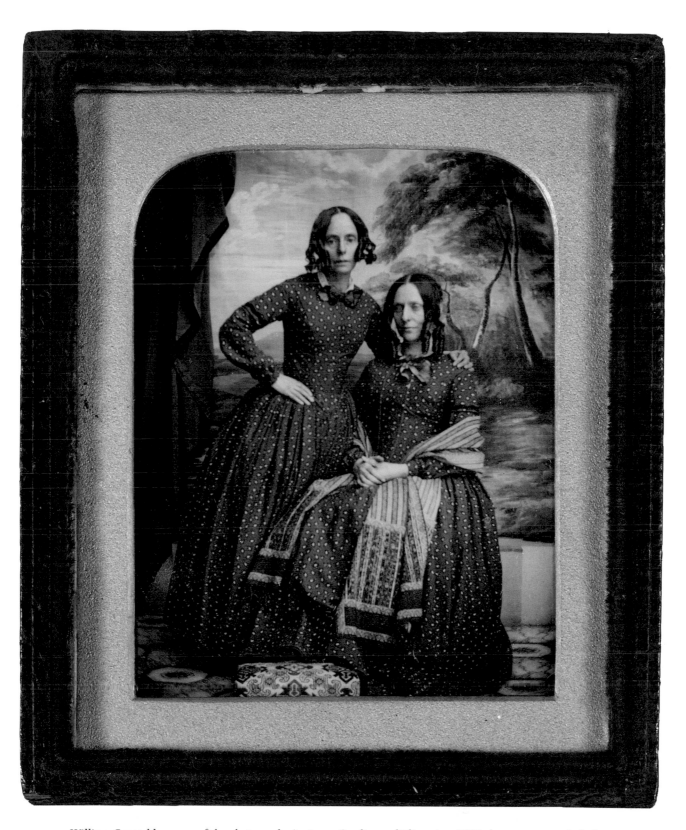

William Constable, group of the photographer's nieces, Caroline and Eliza, circa 1845, daguerreotype, *ninth plate*

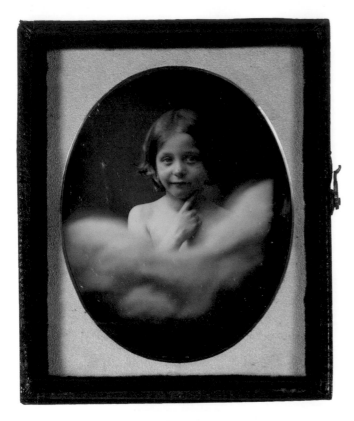

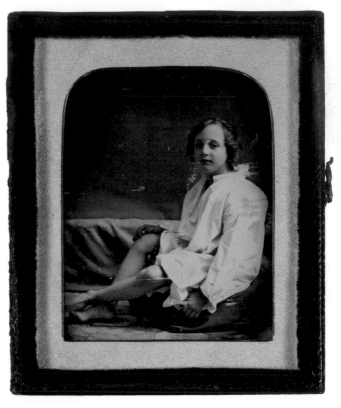

William Constable, study of a child, circa 1845, daguerreotype, *ninth plate*

William Constable, study of a seated boy, circa 1845, daguerreotype, *ninth plate*

and Bacon. He took an active part in the cultural life of the town. 'When the British Association met in Brighton [he] would entertain them royally, throwing his house open and giving luncheons, dinners and conversaziones [sic].'[13]

Ellis's first-hand investigation of the discovery and progress of photography was in due course delivered as a paper before the Literary and Scientific Institution of Brighton in the Albion Rooms on the 23rd February 1847. The text was published later in the year by Robert Folthorp of North Street as 'Photography: A Popular Treatise, designed to convey general information concerning the discoveries of Niépce, Daguerre, Talbot, and others, and as preliminary to acquiring a practical acquaintance with the art'. Ellis's essay remains impressive in its thorough and even-handed account of British and French achievements. He discusses the pre-history of the medium, the work of Wedgwood and Davy, the breakthrough of Niépce, the triumphs of Talbot and

Daguerre, and the refinements and variant processes investigated by Bayard, Herschel, Claudet, Fizeau and others. In his Preface he acknowledges his debt to 'the valuable services of Mr Claudet (whom he has mainly to thank for his photographic knowledge)'. Antoine Claudet, the French-born, London-based daguerreotypist, spent time with Ellis. They talked at length and the photographer took the trouble to show and explain examples of the medium to the enthusiast. Their friendship is specifically commemorated in an engraving after a daguerreotype, now lost, made by Claudet of Ellis's Bedford Hotel.

Ellis was driven by a profound curiosity and by a faith in the significance of the new medium and in the authority of the photographic image. His obsession with the image as object, with its quasi-magical presence, is well evidenced in the account of his pursuit of a crucial early plate by Niépce. An unidentified author discussing 'The Oldest Existing Photographs…at a

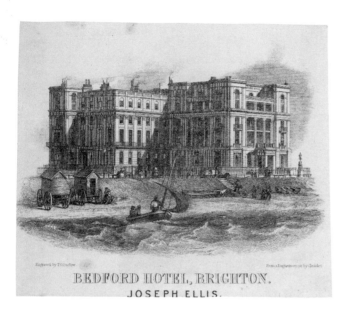

Antoine Claudet, 'Bedford Hotel', circa 1850, engraving by
I.O. Barlow after a daguerreotype by Claudet, *113 x 131mm*

Lombardi & Co., Joseph Ellis, 1882, photogravure, *image 84 x 61mm*
This portrait was incorporated as a frontispiece in certain editions
of Ellis's anthology 'Caesar in Egypt, *Costanza and other Poems*'

recent dinner of "The Photographic Club"' in 1862 explains: 'we had an opportunity of examining one of the most interesting mementoes of early photographic investigation and experiment. It consisted of a heliograph in the possession of Mr. Joseph Ellis, of Brighton, [who] gave some interesting details of the history of the picture, and of his possession of it. M. Nicéphore Niépce...in the year 1827 visited this country, in the vain hope of being able to obtain the attention of the Royal Society. It appeared that he resided at Kew, and the picture in question had been given by him to his landlord at that time..., [Mr] B. Cassell.... Mr. Ellis had seen it in Mr. Cassell's possession some years ago, and desired to obtain it. Mr. Cassell refused, however, to part with it, regarding it with almost superstitious regard and reverence. For the time, Mr. Ellis had to waive his desire, resolving, however, to keep an eye upon it. He recently learnt that the owner had died, and found, on enquiry, that his effects had been sold by auction. A little search discovered this picture in the

hands of a broker, whose chief idea of its value was based on the notion that it was executed on silver. The back had been scratched to test it and it is to the fact that the metal used was pewter and not one of the noble metals, that this interesting memento, probably one of the earliest sun pictures in existence, was saved from the melting pot. Mr. Ellis purchased the picture and preserves it with the care naturally pertaining to a picture possessing such historic value.' And doubtless he did so with a superstitious reverence at least as intense as that demonstrated by Cassell before him.[14]

The author finally refers his readers 'interested in the historic details of photography' to the 'couple of published lectures of Mr. Ellis who, with considerable research, has carefully, and with much ability, traced the earliest known facts, evidently entering upon the task as a labour of love'.[15] The second lecture, 'Progress of Photography. Collodion, the Stereoscope', was first presented on the 13th November 1855 before the

Literary and Scientific Institution. On this occasion 'Mr Ellis exhibited a large stereoscope, on Professor Wheatstone's construction, a Pseudoscope, and a great number of very beautiful photographic pictures, – some on albumen, others on collodion, – Talbotypes, etc.'[16] Ellis brings his audience and subsequent readers up to date with new developments that were affecting the medium in Brighton as elsewhere. The text was published in 1856. A copy dedicated in ink to 'Henry Fox Talbot Esquire from Joseph Ellis' was carefully preserved by the recipient on the shelves at his home, Lacock Abbey, in Wiltshire. If he were as assiduous in his pursuit of

Joseph Ellis, 'Progress of Photography. Collodion, the Stereoscope', 1856, with manuscript dedication to '[William] Henry Fox Talbot', published by Robert Folthorp, *214 x 138mm*

Talbot as he had been in tracking the Niépce plate, Ellis may well have been in contact with him from the very start of his researches.[17]

William Henry Fox Talbot, the inventor of the positive-negative process, had been an occasional visitor to Brighton in the early 1840s. It was in February 1846 that he made his only recorded images in the town, the earliest known photographs of Brighton. Early in the month, on the ninth, Talbot had photographed Sir Charles Barry's St Peter's church. Two days later, he set up his camera in the first floor bay window of 11 Pavilion Parade, rented for him by his assistant Nicolaas Henneman, and pointed his lens towards the onion domes and minarets of the Royal Pavilion. The resulting images of this wild and enchanting architectural fantasy are the only photographs of the Pavilion from the period of its Royal ownership. One image shows discreet evidence of this – a sentry box. The sale of the Pavilion by the Crown was announced in August of that year, and it was bought by the town in 1850.[18]

William Constable, Joseph Ellis and William Henry Fox Talbot – three lives with common threads – the town of Brighton, its residents and visitors, its Pavilion and Parades, and the new alchemy, capable of turning the fugitive moment into a permanent record. Two committed picture makers and a passionate chronicler who, with their families and associates, followed a destiny to record, to fix, to preserve, and so to leave traces for future generations.

1. *Brighton Gazette*, 11 November 1841
2. 1 January 1844
3. Letter to Susanna Grece, 14 November 1841
4. Letter to Leone Glukman, 13 February 1848
5. Susanna Grece's Journal, 17 February 1842
6. Susanna Grece's Journal, 26 February 1842
7. Susanna Grece's Journal, 5 and 7 March 1842
8. Letter to Leone Glukman, 1 June 1846
9. Susanna Grece's Journal, 22 March 1842. A daguerreotype matching this description is in the collection of the Smithsonian Institution, Washington, D.C.

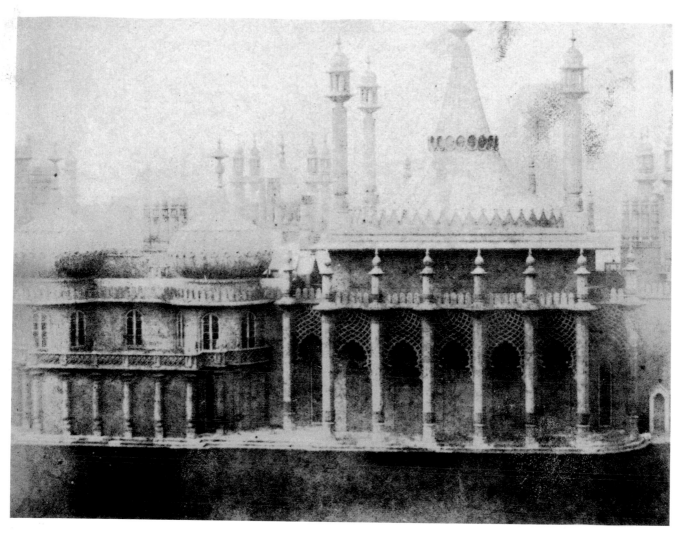

William Henry Fox Talbot, part of the east facade of the Royal Pavilion, 11 February 1846, calotype, *133 x 174mm*
A sentry box, a symbol of Royal ownership, is visible on the right of the image

10. Laura Hain Friswell, *In the Sixties and Seventies – Impressions of Literary People and Others*, Boston, 1906, p. 249

11. 'Progress of Photography. Collodion, the Stereoscope', Brighton, 1856, p. 5

12. 'Death of Mr Joseph Ellis at Brighton', *Brighton Gazette & Sussex Telegraph*, 13 June 1891, p. 5

13. Laura Hain Friswell, *In the Sixties and Seventies – Impressions of Literary People and Others*, Boston, 1906, p. 258

14. The present whereabouts of this Niépce plate are not known

15. 'Talk in the Studio', *The Photographic News*, 11 July 1862, p. 336

16. 'Royal Literary & Scientific Institution, Albion Rooms', *Brighton Herald*, 24 November 1855, p. 4

17. No correspondence between Ellis and Talbot is recorded

18. See: Larry Schaaf, *The Photographic Art of William Henry Fox Talbot*, Princeton and Oxford, 2000, pl. 99, p. 231, and text and notes pp. 230 and 257–58. Schaaf erroneously states that William Constable made a photographic portrait of Queen Victoria. He photographed Prince Albert but not Queen Victoria

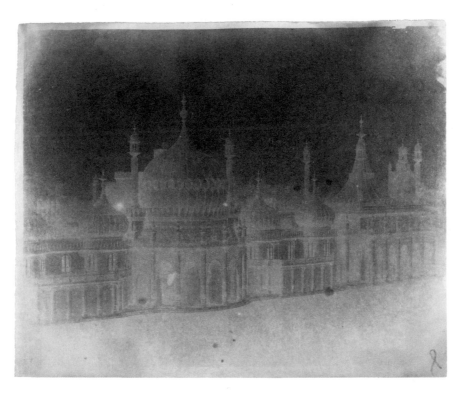

William Henry Fox Talbot, the Royal Pavilion, 11 February 1846,
calotype negative, *95 x 114mm*

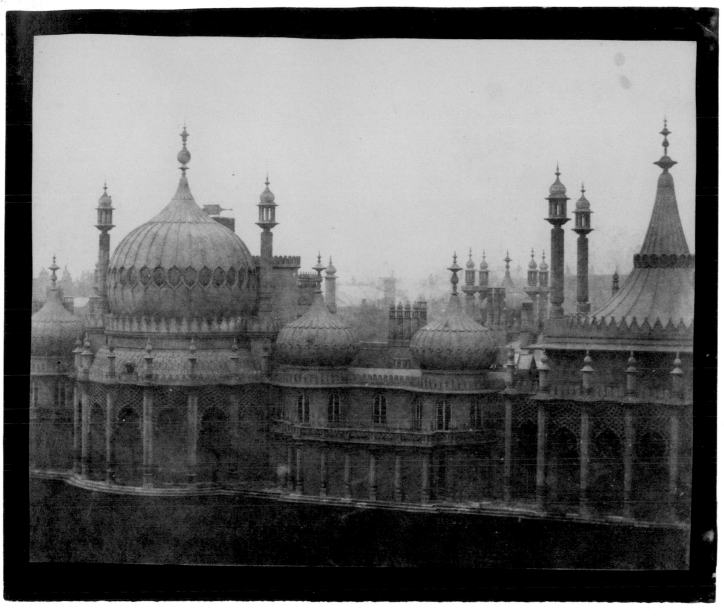

William Henry Fox Talbot, the Royal Pavilion, 11 February 1846, calotype, *187 x 224mm*

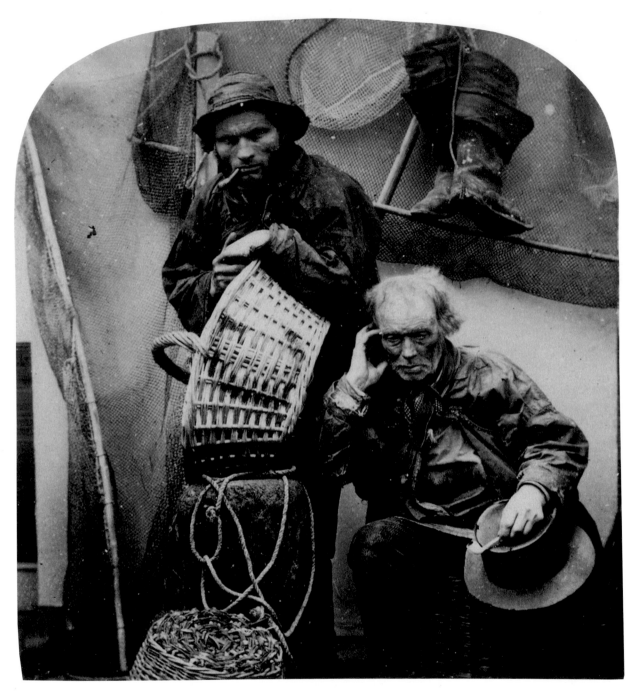

William Mason Junior, 'Brighton Fishermen, Waiting for the Tide', late 1850s,
albumen print, one of a stereoscopic pair

CONSOLIDATION – art, science and commerce

The sign-maker's task involved setting the name of a new photographic studio, the Brighton Talbotype Portrait Gallery, on a slender strip the full width of 108 King's Road, at the upper edge of the projecting ground floor gallery of another business, W.H. Mason, Repository of Arts. Further signs were positioned on the pillars that flanked the facade. The new studio, established in 1852, was the foremost of the second generation to be opened in Brighton, breaking the monopoly enjoyed for a decade by William Constable. The venture was the result of an agreement between William Mason and Thomas Henry Hennah and his partner to create portrait rooms on the recessed upper floors of the building, with access through the street-level art shop. The businesses would complement one another. Examples of Hennah & Kent's work were displayed in Mason's window, demonstrating to passers-by the quality of the service offered upstairs. Shop customers might be tempted by the prospect of sitting for a fine portrait, and portrait sitters could

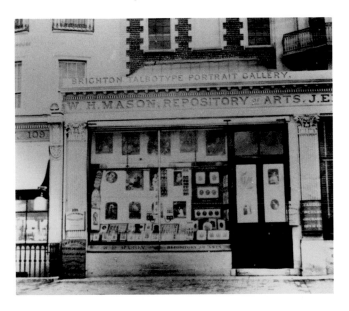

Attributed to William Mason Senior or Junior,
108 King's Road, circa 1855–60, silver print copy of
unlocated original, *87 x 99mm*

Hennah & Kent, portrait of a lady, 1850s,
salt print, 121 x 154mm

equally be tempted by Mason's merchandise – by frames, or such special products as his 'Photographic Cement Paper, For Fixing Photographs, Prints, Drawings, &c., into Albums and Scrap Books'. This mutually beneficial arrangement was to flourish till 1873, and for a decade beyond that Hennah & Kent occupied the premises alone as the King's Road Art Studio. The association was consolidated by the enlistment of William Mason Junior as principal assistant to Hennah. Next door, at 109 King's Road, were the premises of [William] Cornish, Dispensing Chemist. Art and science side by side – perhaps an appropriate metaphor for photography itself. And Cornish's son, also called William, was, like his young neighbour, to take an early interest in photography.

Thomas Hennah had a keen curiosity for the chemistry of his chosen medium. He published a handbook in 1853, 'Plain and practical directions for obtaining both positive and negative pictures upon glass by means of the collodion process. Also Gustave Le Gray's method of obtaining black and violet colours in the positive proofs by the use of chloride of gold'. He would print his own glass negatives onto salted papers, achieving a distinctive greyish tint, his refinement of the process invented by Talbot. 'We worked a salted paper,' recalled one of his assistants, 'of which the firm was so proud that one of the partners sensitized it at his home in order to guard the secret.'[1] In 1855, Hennah exhibited Brighton and Sussex views, as well as cloud studies, at the London Photographic Society. His studio specialised in uncluttered, somewhat austere, yet direct and engaging half-figure studies. These would often be mounted on presentation card with the firm's blind-stamped credit, the earliest productions incorporating the acknowledgement 'By licence of [Talbot] the patentee'. Distinguished early sitters included the Duke of Devonshire, who had earlier been photographed by Constable,[2] the Reverend Henry Wagner, Vicar of Brighton, and the watercolour artist William Henry Hunt. Hennah & Kent swiftly established a high

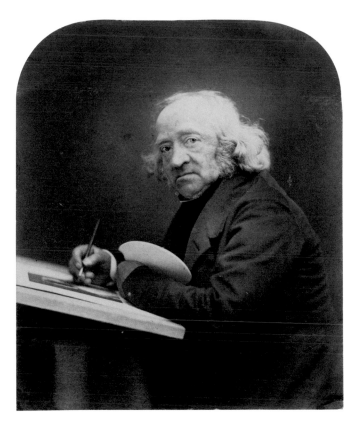

Hennah & Kent, portrait of William Henry Hunt, circa 1852–55,
salt print, made 'By licence of [Talbot] the patentee', *134 x 111mm*

reputation as the pre-eminent artistic portrait studio in the town.

By 1857, their apprentice, William Mason, was attracting critical attention for his independent achievements. In that year, *The Art-Journal* announced that 'A series of stereoscopic views, of very conspicuous merit, has been issued by Mr. Mason, the well-known and much respected [Brighton] print-seller.... They are the production of his son, a young and promising artist, who has studied in a good school, – that of M. Henneh [sic], whose principal assistant he is. The photographs consist of various subjects – out-door and in-door scenes, dead game, figures in repose and in action, and so forth. They are cleverly grouped and arranged, and "tell" with good effect in the stereoscope, giving high relief, and being singularly free from blemishes.'3 Mason's successes include most notably his genre studies. With such subjects as 'Brighton Fishermen, Waiting for the Tide', 'Our Laundry Maid', 'Our Housemaid', 'The

Brighton Fancy Basket Maker' and 'Italian Boy' he explored new documentary possibilities for the medium. His neighbour, William Cornish Junior, made a less ambitious foray into stereoscopic photography. He captured, nonetheless, a few compelling images, intimate scenes of local life such as boys playing cricket in a yard and men posing beside the cannons removed in January 1858 from the dismantled Battery, a last echo of the threat from Napoleon.

By mid-decade, the practise of photography was acquiring a momentum. The Brighton and Sussex Photographic Society was established in the summer of 1855. 'The fifth monthly meeting was held in the Council Chamber, Town-hall, on Monday, the first instant,' wrote a correspondent, 'when a communication was made by J. Hall, Esq., on "Photography in connexion [sic] with the fine arts." At the four previous meetings papers were read on the various photographic processes: at the first, "On Calotype," by the Rev. W.F.W. Watson; at the

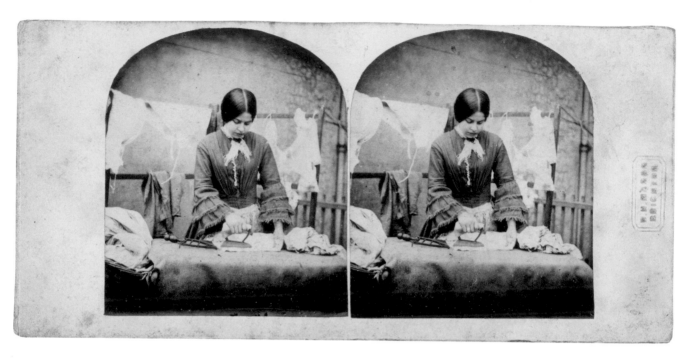

William Mason Junior, 'Our Laundry Maid', late 1850s, stereoscopic pair of albumen prints

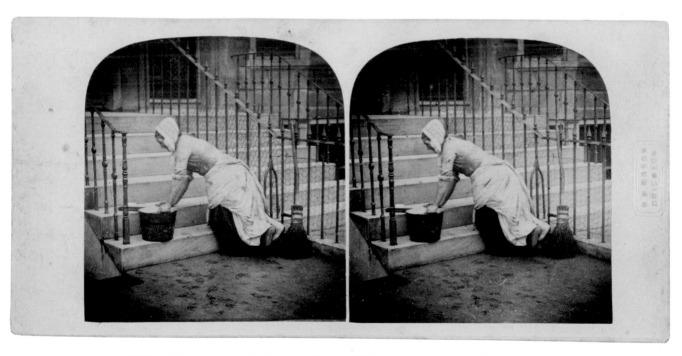

William Mason Junior, 'Our Housemaid', late 1850s, stereoscopic pair of albumen prints

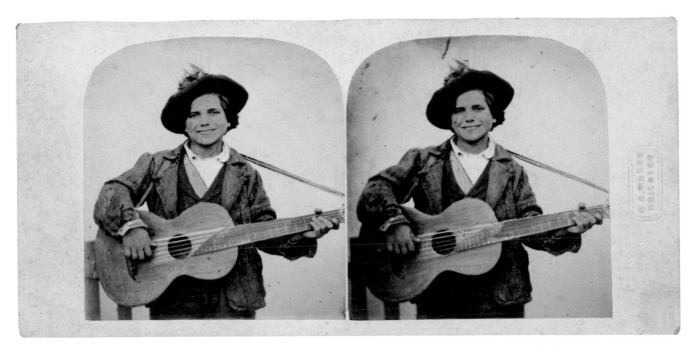

William Mason Junior, 'Italian Boy', late 1850s, stereoscopic pair of albumen prints, hand coloured

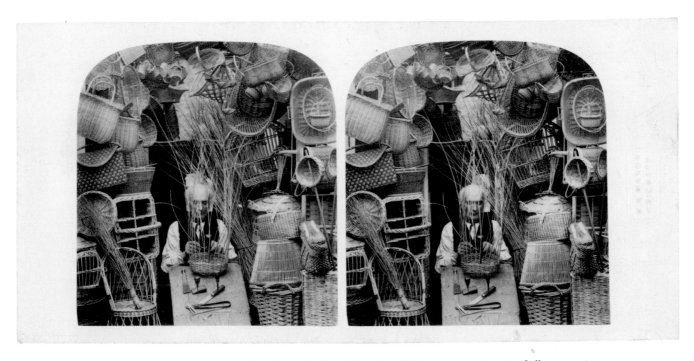

William Mason Junior, 'The Brighton Fancy Basket Maker', late 1850s, stereoscopic pair of albumen prints

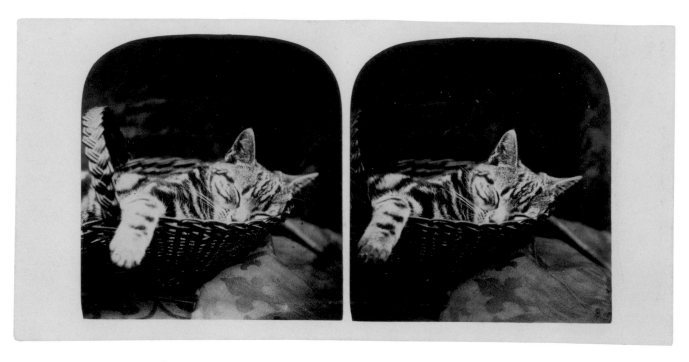

William Mason Junior, sleeping cat, late 1850s, stereoscopic pair of albumen prints

second, "On Daguerreotype," by Mr. E. Collier [partner with William Constable in the mid-1850s]; at the third, "On the Waxed Paper Process," by Mr. E. Streeter; and at the fourth, "On the Collodion Process," by Mr. E.B. Stamp. These meetings having been well attended and ably supported by discussion, augur well for the future career of the society, and considering that its enrolled membership now number 40, after establishment of four months, we think it bids fair to rival some of the older societies.'[4]

The local *Directory* for 1854, the first to identify the practise of photography, had listed ten studios under 'Artists. Daguerreotype'.[5] The previous August, Lewis Dixey, optician, of 21 King's Road, was advertising 'Photographic Apparatus and Materials, comprising Cameras…Lenses…Chemically pure preparations, iodized and plain papers…and every requisite for practising this most interesting art'.[6] Two weeks later, the Royal Chain Pier Photographic Rooms advertised

'Portraits superior to engravings by the new process on glass', and announced: 'This fascinating art taught, including the Talbotype and Calotype printing on paper; perfect, in three lessons, one guinea. Amateurs taught in one lesson, 10s 6d.'[7] In November and December 1855, Robert Farmer, established as a photographer since 1852 at 59 North Street, placed advertisements in several journals. These promoted his 'Photographic views of Brighton: Its beach and its buildings', listing thirty subjects including genre studies, and suggesting that they might contain 'many valuable suggestions to the Artist, Architect and Amateur'.[8] Such notices and the substantial membership of the new Society confirm that interest in the medium was now extending to amateur as well as professional practise, and to those interested in the photograph's status among the arts.

By 1859, the number of 'Photographic and Talbotype Artists' listed in the *Directory* had increased to sixteen.[9] These included two men of contrasting aspiration,

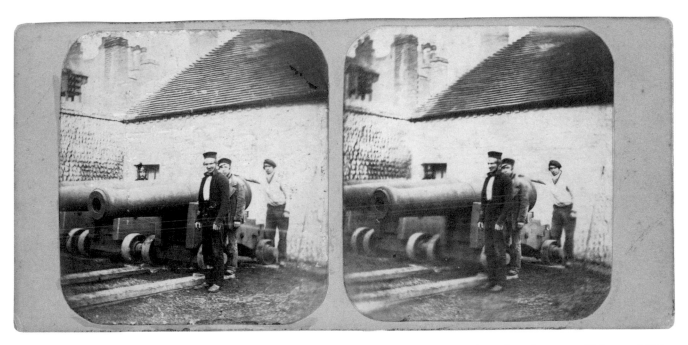

William Cornish Junior, 'Guns at back of Battery House', figures with cannons removed from the seafront battery on 27 January 1858, stereoscopic pair of albumen prints

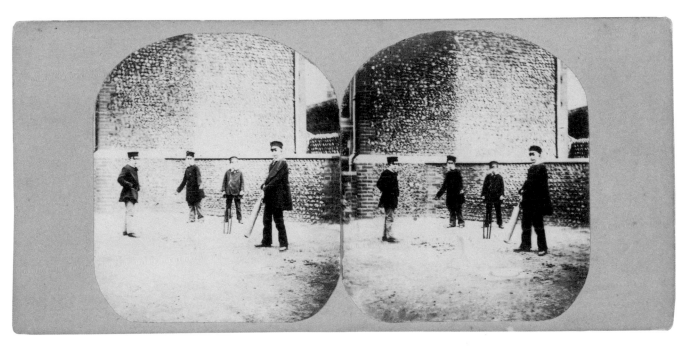

William Cornish Junior, boys playing cricket in Westfield Gardens, late 1850s, stereoscopic pair of salt prints

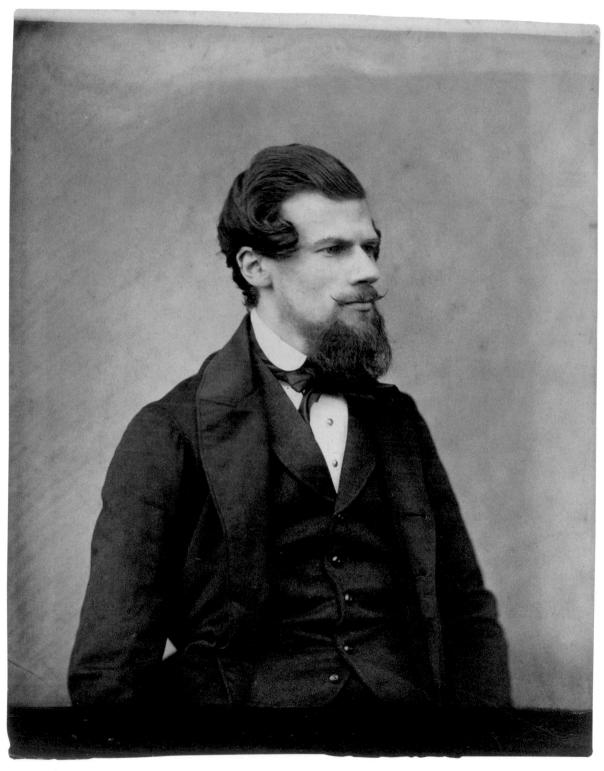

George Ruff, self portrait, circa 1860, albumen print, *142 x 112mm*

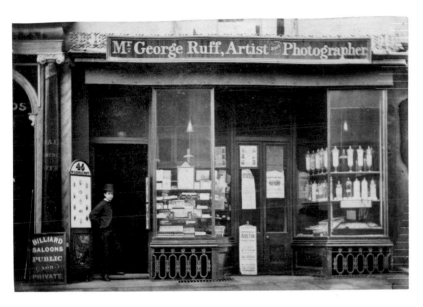

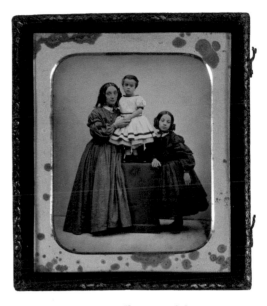

George Ruff, the photographer's premises, 45 Queen's Road, his son, George Ruff Junior, posed on the doorstep, dated February 1872 in a later, family hand, albumen print, *67 x 97mm*

George Ruff, group of the photographer's wife and children, circa 1860–62, hand coloured ambrotype, *sixth plate*

George Ruff and Samuel Fry. Ruff, who styled himself 'Artist and Photographer' when he set up his portrait studio in 1855, was born in 1826. His father was a shoemaker while his mother became a fruiterer and greengrocer.[10] His watercolour studies of life on Brighton beach reveal an innate desire to depict, and suggest an ambition to live by his art. Photography allowed him an effective and commercially viable way to achieve his ambition. From his studio at 45 Queen's Road, on the route from the station due south to the sea, he built a business making fine collodion positive, or 'ambrotype' portraits. Presented with gilt-metal surrounds in velvet-lined leather cases, gold embossed with his logo, his production was characterised by hand colouring of exceptional delicacy – 'The pictures are produced throughout by Mr. and Mrs. Ruff, (no assistants being kept) consequently the finish can be depended upon. The colouring being executed entirely by Mr. R. himself, (an *Artist* independent of Photography,) will be found all that can be desired.'[11] George Ruff founded his success on these exquisitely crafted keepsakes of the features of loved ones. None was more precious than the group he

executed for himself of his wife and their two children. The young boy in the family portrait, George Ruff Junior, was to carry on to considerable effect, at the turn of the century, the tradition of commitment to the photographic medium established by his father.

Samuel Fry showed a curiosity of a different kind, that of the scientist as well as of the artist. While advertising 'Talbotype Portraits in the Highest Style of Art',[12] he also wanted to freeze time, to master the 'instantaneous' exposure, and he did so in a series of sea studies published in February 1859. Fry's achievement was commended: 'We have recently seen a fine instantaneous photograph, produced by Mr. Fry, late of Brighton'.[13] Nor was his spirit of enquiry limited to this planet. 'My attention was first called to the photography of the moon, at the commencement of 1857,' he wrote, 'by having placed at my disposal the very fine equatorial telescope of Charles Howell Esq…which had just then been erected in a suitable observatory on the beach, about a mile from the town. I determined to commence operations at once.'[14] He succeeded in his endeavour and was assisted

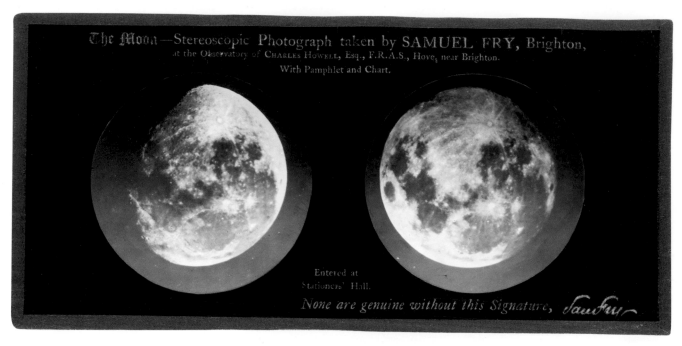

Samuel Fry, the moon, 1857, stereoscopic diapositive on glass

to this end by Antoine Claudet who 'was with [him] one evening at the observatory',[15] and helped him with the technicalities of focus.

Through the 1850s, Brighton and its people became the subject of varied photographic approaches. The medium was explored by an extended group of practitioners who used the camera in pursuit of art, of science and of commerce. All unwittingly reinforced a sense of identity and of place, and in so doing consolidated a sense of community and continuity. In August 1859, one of Talbot's close friends and associates, the Reverend Richard Calvert Jones, visited the town and made a series of sketches, both in pencil and wash and with his camera. He was in pursuit of a mid-century notion of the picturesque and he found it in the beach vistas, and in the structures, detail and texture of fishing boats, net huts and capstans. The time was ripe for Brighton to inspire its local photographic master of the picturesque.

1. 'A.H. Fry Brighton', *The Professional Photographer*, June 1916, p. 163

2. A print of this image is in the archive at Chatsworth House, Derbyshire

3. *The Art-Journal*, 1857, p. 385

4. *Liverpool & Manchester Photographic Journal*, 13 October 1855, p. 122

5. *The Original Brighton and Hove Directory; including Cliftonville*, Brighton, July 1854, p. 341

6. *Brighton Examiner*, 15 August 1853

7. *Brighton Herald*, 1 October 1853

8. Most fully detailed: *Liverpool & Manchester Photographic Journal*, 8 December 1855

9. *Folthorp's Court Guide and General Directory for Brighton and Hove and Cliftonville*, 1859, p. 401

10. From author's conversation with Dorothy Ruff, the photographer's adoptive grand-daughter, circa 1975

11. Printed label on backing of ambrotype

12. Promotional leaflet, 1859

13. *The Photographic News*, 16 November 1860, p. 348a

14. *The Photographic Journal*, 15 January 1861, p. 80

15. Ibid

Samuel Fry, the Old Steine, late 1850s, albumen print, *150 x 189mm*

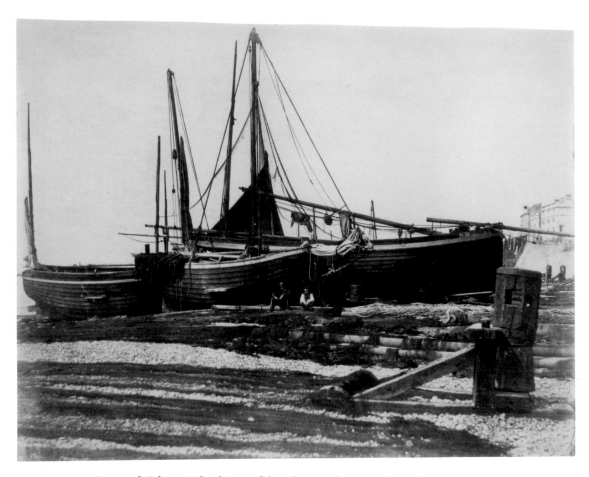

Reverend Calvert Richard Jones, fishing boats and nets on the beach, August 1859,
albumen print from paper negative, *195 x 245mm*

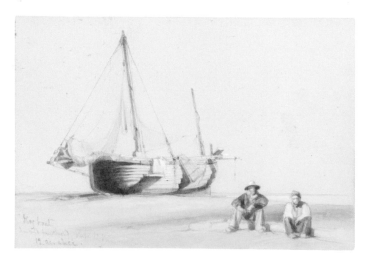

Reverend Calvert Richard Jones, fishing boat and fishermen,
August 1859, pencil and watercolour, *177 x 257mm*

Reverend Calvert Richard Jones, nets and storage huts on the beach below Black Lion Street, August 1859, albumen print from paper negative, *197 x 246mm*

Edward Fox, farm scene, late 1850s, waxed paper negative, *119 x 100mm*

EDWARD FOX – 'landscape and architectural photographer'

There survives an album of photographs of Sussex scenes of the early 1860s, of ruins and of harvest, of village streets, and of figures in landscapes. The images are by Edward Fox, and he has pasted them onto the pages of an empty sketchbook. A manuscript inscription on the inside back cover, though possibly in his father's rather than his own hand, gives an indication of the artistically informed context and the spirit in which these images were conceived. It reads 'Light & shade & colour, Burnet – Remarks on Teniers, Rembrandt, Vandevelde &c. E. Fox, Shades of Effect'. Several fine photographic prints by Fox, including a glorious seascape, were included in a mixed album of images from the 1850s and 1860s compiled by the family of the Hon. Arthur Kerr. On the first page is the calligraphic inscription 'Souvenir Book of Friendship Beauty Art'. Fox was drawn to photography in the first golden summer of the artist amateur.

Edward Fox Junior lived at 44, Market Street with his parents and brothers. His father was an artist, his mother a milliner. Edward Senior had exhibited regularly at the Royal Academy and the British Institution and was recognised for his Brighton and Sussex scenes. A series of his views of the promenade in Regency times were published as lithographs. Edward Junior's eye was formed in this household, and he followed in his father's tradition, working as a 'decorative painter' before becoming an 'artist-designer, photographer'.[1] He was in his mid-thirties when, in the late 1850s, he turned his hand and artistic attentions to photography.

Fox's first endeavours were with the waxed paper negative process and his achievement was a series of studies that embraced the picturesque aspects of the natural and man-made environment. A review of the 1852 Society of Arts exhibition of photographs had defined the prevalent pre-occupation with '…representations of the peaceful village; the unassuming church, among its tombstones and trees; the gnarled oak, standing alone in the forest…shocks of corn…the quiet stream…and

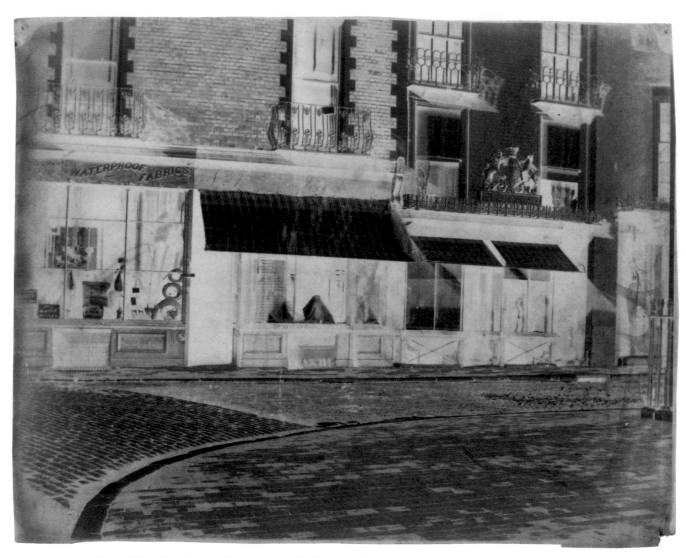

Edward Fox, Ship Street at the junction with King's Road, late 1850s, waxed paper negative, *178 x 224mm*

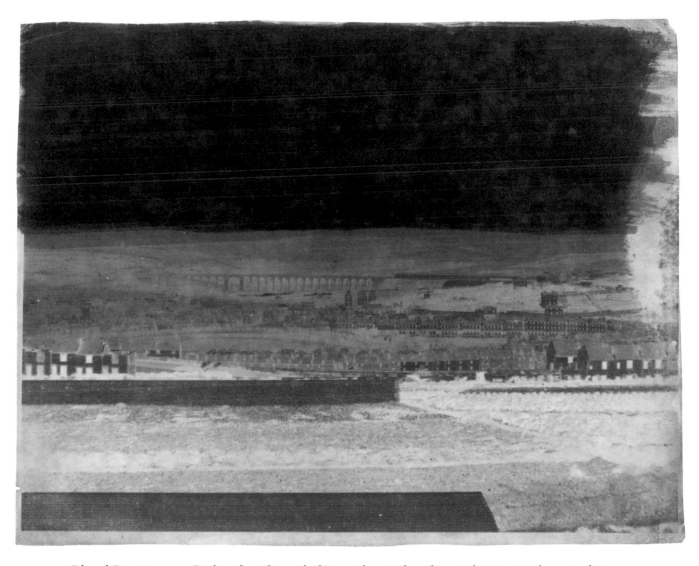

Edward Fox, view across Brighton from the east looking north-west, the railway viaduct crossing the centre distance, late 1850s, waxed paper negative, *182 x 230mm*

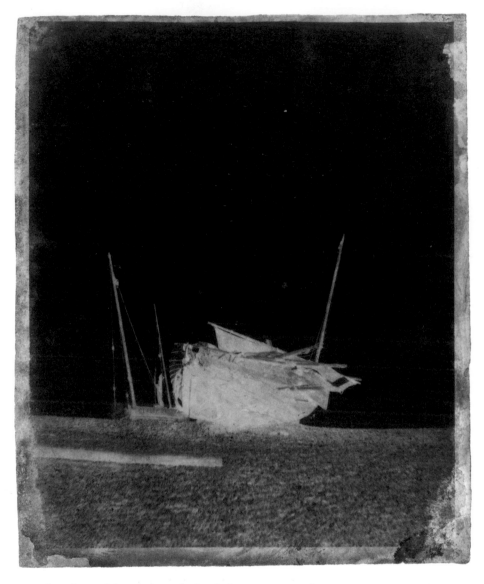

Edward Fox, fishing boat on the beach, late 1850s, waxed paper negative, *118 x 98mm*

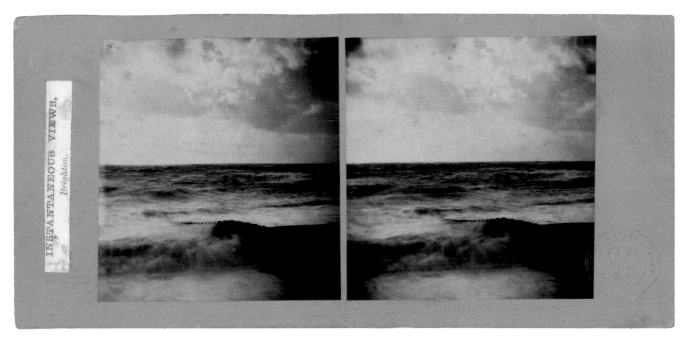

Edward Fox, 'Instantaneous Sea View', 1863, stereoscopic pair of albumen prints

rustic bridge…'.[2] Fox's subject matter reflects the widespread pursuit by artists of his generation of texture and detail, of the romantic, and of the sublime. Antiquarian investigations become a dialogue on transience; land, sea, and sky are imbued with transcendental power.

By the early 1860s, Fox was active as a 'landscape and architectural photographer',[3] registering his copyright on images embracing a widening range of subject matter.[4] He registered and published a series of 'Instantaneous sea views' in small stereoscopic format in 1863,[5] undertaking more ambitious larger format 'cloud & sea' studies two years later.[6] Fox's camera effectively captured the fugitive, luminous moments sketched earlier by Constable and Turner.

An advertisement from this period announces 'Landscape photography. Mr. Edward Fox, Artist, 44, Market Street, Brighton. Private Photographic Views, monuments, copies of sculpture, interiors, and instantaneous portraits of animals, groups, &c. Taken in Brighton or the country. Local views & stereoscopic slides…'.[7]

Through the winter of 1864–65 and the following summer, Fox undertook a most individual project. He published the first results in the autumn of that year as 'The Anatomy of Foliage: Photographed examples of the principal Forest trees, each taken from the same point of view in winter & in summer; enabling the student to trace the limbs when hidden by the masses of foliage…'.[8] The publication was arranged through Thomas Hatton of Ship Street, author of *Hints for Sketching Trees from Nature in Watercolour*. His name is featured in advertisements placed in *The Athenaeum* between December 1865 and the following September.[9] A local review is fulsome in its admiration: 'Our townsman, Mr. Fox, has done wonders. Scenes from sea & sky have been transfixed in a moment. The rolling wave & the fleeting cloud have been arrested in their career & compelled to sit for their portrait. And in the

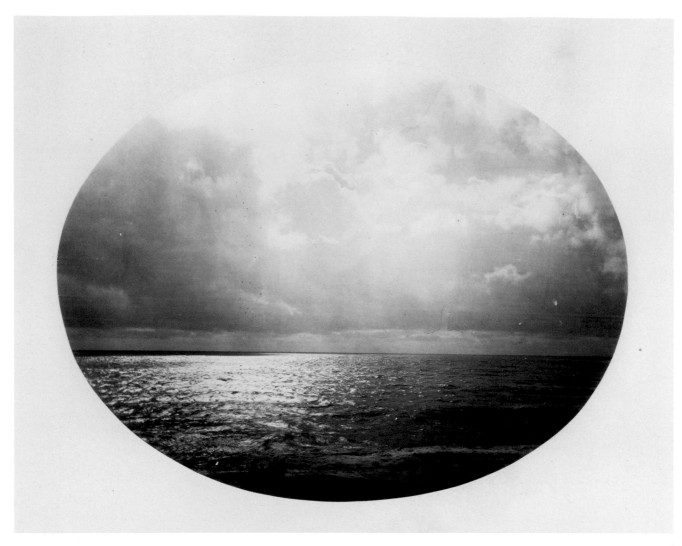

Edward Fox, 'Instantaneous Photograph – Sea & Sky Scene', 1865, albumen print, *136 x 202mm*

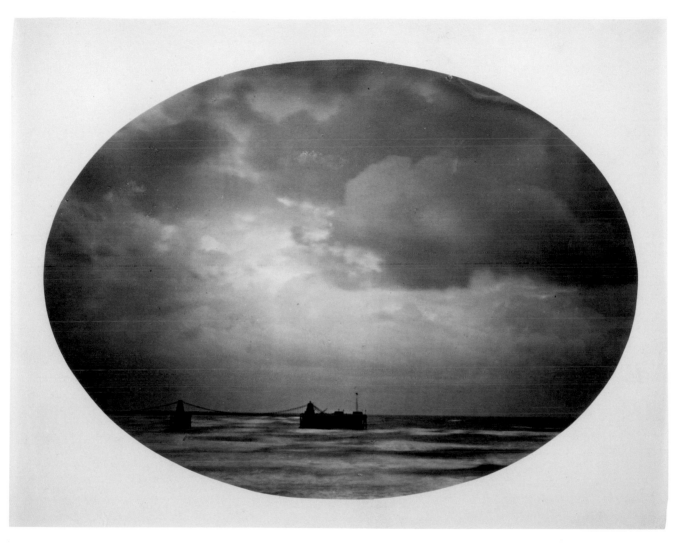

Edward Fox, 'Cloud & Sea no. 38', probably 1866, albumen print, *169 x 216mm*

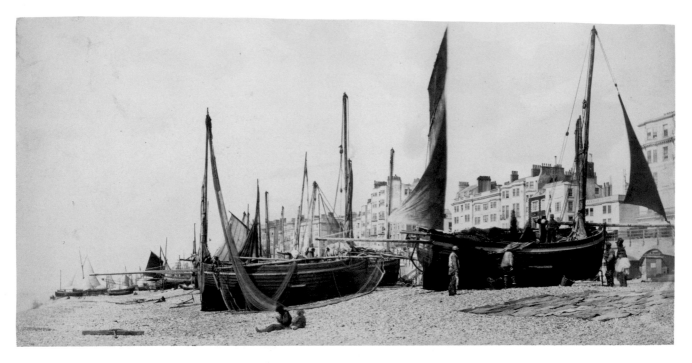

Edward Fox, 'hog' boats and fishermen, early 1860s, albumen print, *137 x 276mm*

summer just gone by, unequalled perhaps in length and brilliancy, and calmness, the same enchanter has compelled the monarchs of the forest also to stand before his magic lens & deliver up their treasures…the photographic witness is unimpeachable.'[10]

Edward Fox was Brighton's principal photographic witness through the 1860s and beyond. He recorded architecture, old and new, panoramic vistas of the promenade, the fishing fleet and the activities of the fishermen, news events such as the wreck of the French brig Atlantique opposite the Albion Hotel on the 2nd June 1860. This eminent documentary and visionary artist made a significant pictorial record of the town and its life, while pursuing his own aesthetic concerns. In 1892, he announced: 'Mr. E. Fox, artist and landscape photographer (late of 44, Market Street)…respectfully solicits a visit from his old friends and others to inspect his collection of oil paintings and original photographs, which he is desirous of disposing of at exceptionally low prices.'[11] *Sic transit….* A significant proportion of

Fox's surviving work, including over eighty paper negatives, numerous albumen prints, drawings, papers and the above-mentioned personal album, surfaced in 1977 in the hands of dealers in antiquarian books and Japanese works of art in Duke Street, Brighton, restoring a key lost link with the past.

1. Census returns, 1851 and 1861
2. Quoted: Carolyn Bloore and Grace Seiberling, *A Vision Exchanged – Amateurs and Photography in mid-Victorian England*, London, 1985, p. 6
3. Credit stamp on verso of several of his prints
4. Public Record Office, copyright registration archive, from no. 410, 15 December 1862
5. PRO, nos. 200–02, 11 November 1863
6. Manuscript title on verso of his prints
7. *Treacher's Brighton Almanack*, circa 1863
8. *Brighton Gazette*, 23 November 1865
9. *The Athenaeum*, various issues between no. 1991, 23 December 1865, p. 868, and no. 2030, 22 September 1866, p. 380
10. *Brighton Gazette*, 23 November 1865
11. *Brighton Herald*, 4 June 1892, p. 1

Edward Fox, 'Horse chestnut no. 4', winter 1864–65, albumen print, *213 x 285mm*

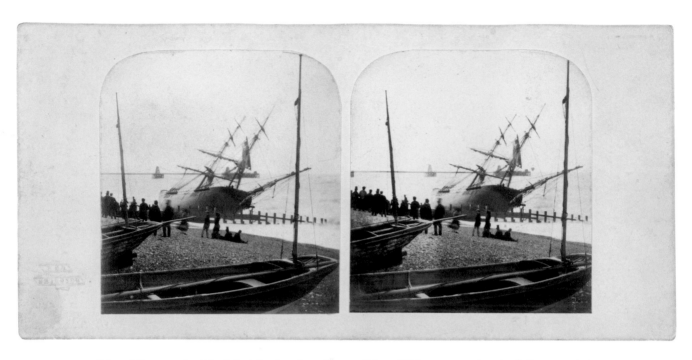

Edward Fox, wreck of the brig Atlantique from Nantes, 2 June 1860, stereoscopic pair of albumen prints

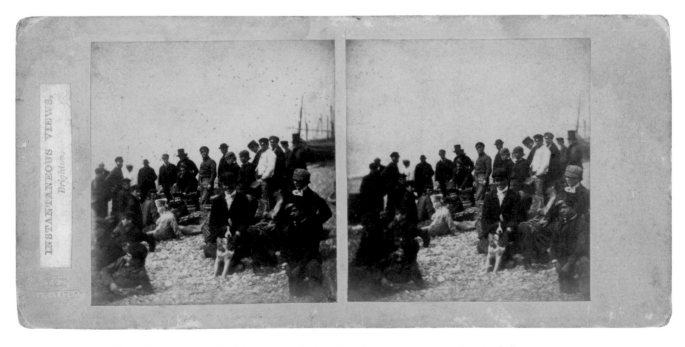

Edward Fox, group with fishermen on the beach, early 1860s, stereoscopic pair of albumen prints

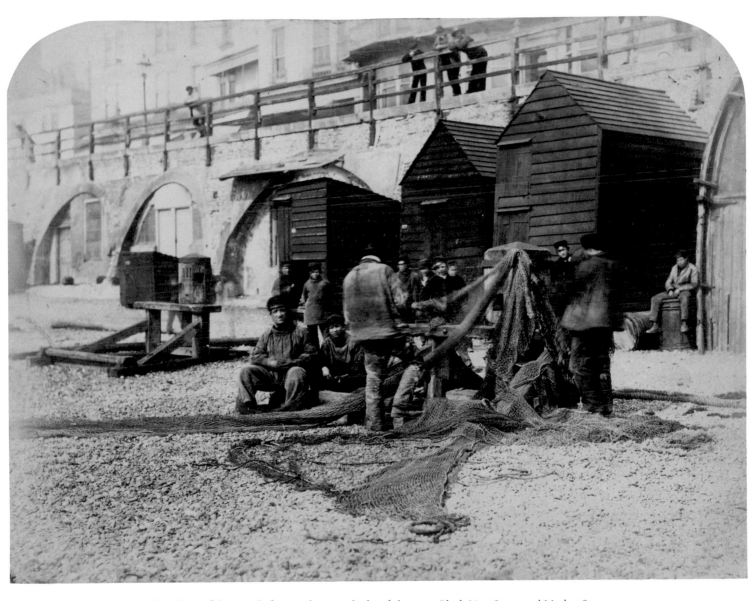

Edward Fox, fishermen before net huts on the beach between Black Lion Street and Market Street, early 1860s, albumen print, *164 x 214mm*

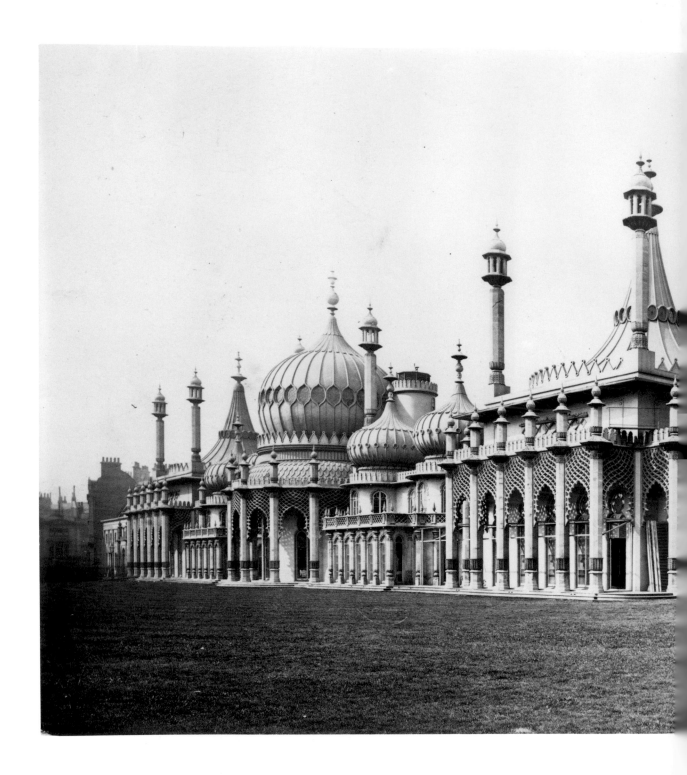

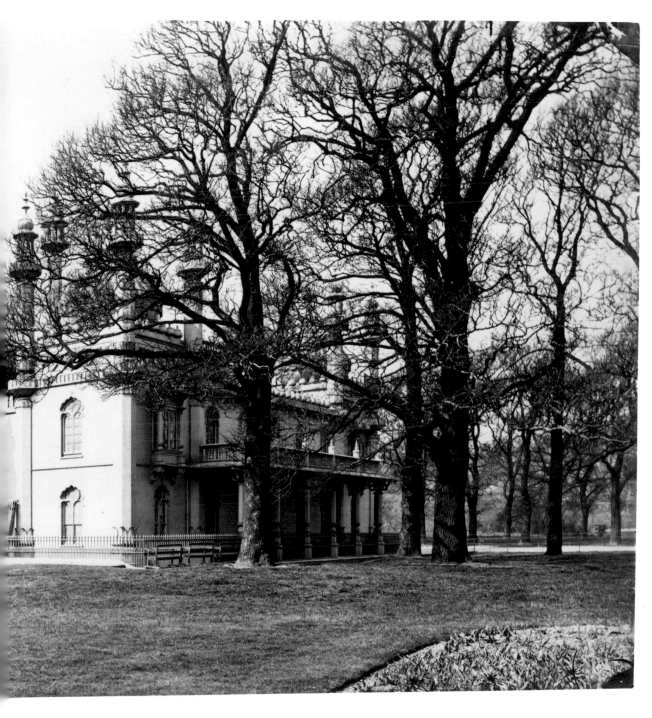

Edward Fox, the Royal Pavilion, probably late 1866 or early 1867, copyright registered
8 April 1867, albumen print, *131 x 277mm*

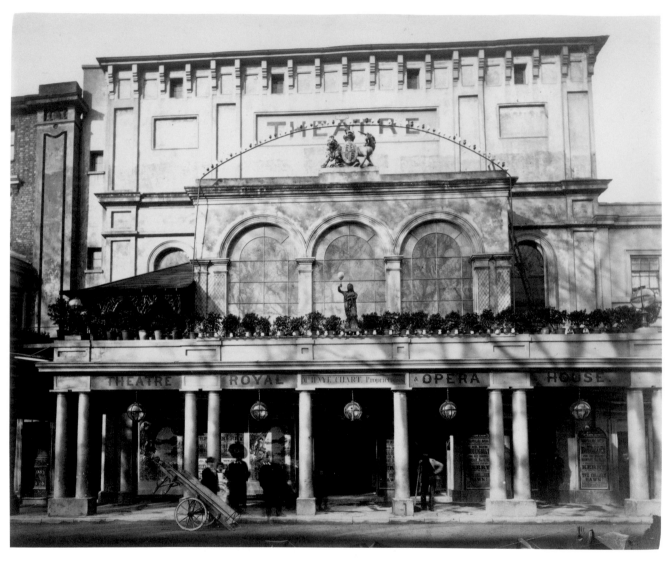

Edward Fox, the Theatre Royal, New Road, week of 6 November 1882, albumen print, *219 x 268mm*

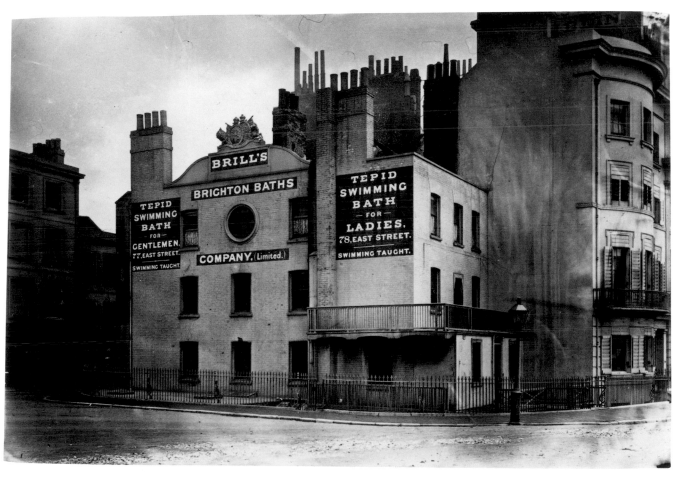

Edward Fox, Brill's Baths, King's Road, 1860s, albumen print, *105 x 154mm*

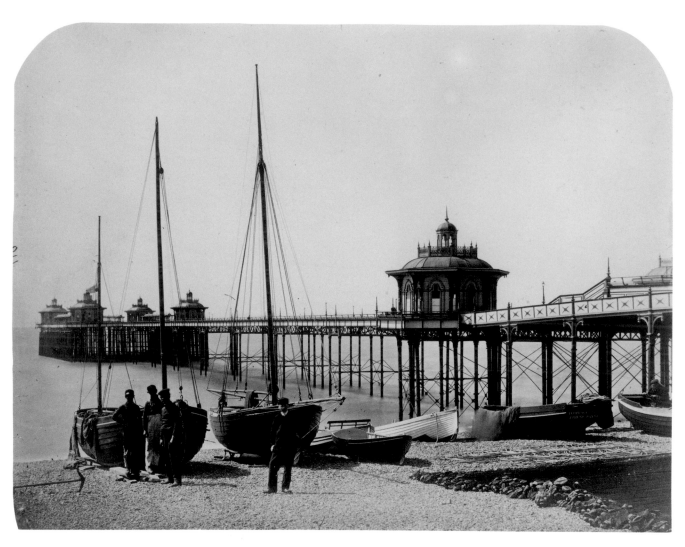

Unknown photographer, the West Pier shortly after its opening in 1866, albumen print, *163 x 200mm*

PHOTOGRAPHY AT
LONDON-SUPER-MARE

The face of Brighton was changing. The Grand Hotel opened for business in July 1864. Two years later, the construction was completed of the new West Pier, an elegant tracery of marine architecture conceived as a generous extended promenade punctuated with small pavilions. And in the summer of 1872, the finishing touches were put to the new Aquarium. Its distinctive ornamental clock tower was built two years later. The town is enthusiastically described in 1872 as 'a large, fashionable maritime suburb of London...its floating (in the sense visiting) population being no less than thirty thousand, while its resident population is said to be nearly a hundred thousand'.[1] The author explains that, as befits such a prominent resort, 'There are many photographers in Brighton, and, speaking of their average productions, we would say that the artistic work is somewhat higher than that of the metropolis, there being, so far as we could see, fewer of the "baser sort" of professional photographers in Brighton than in London. In one respect the Brighton photographers

enjoy a great advantage over their London brethren – the atmosphere is clear and the light excellent.'[2]

The photographic trade was prospering. 'A visitor to Brighton just now,' writes a correspondent in *The Photographic News* in 1879, 'cannot fail to be struck with the bright and prepossessing studios in the King's Road and elsewhere. We know, of course, that in this country it is not only in the capital that photographers of the first rank congregate, but that at the chief watering holes they are unusually conspicuous.... At Brighton, as we have said, there are many fine studios. Mr. Mayall, who, our readers may remember, held the proud position of Mayor of Brighton last year, still enjoys the position of premier photographer in the queen of watering places. Mr. Mayall's studio is in the King's Road, and as he spares neither money nor energy to keep abreast of the times, it is no wonder that he is still a successful man.... Messrs Hennah and Kent, and Messrs Lock and Whitfield, have also studios in the

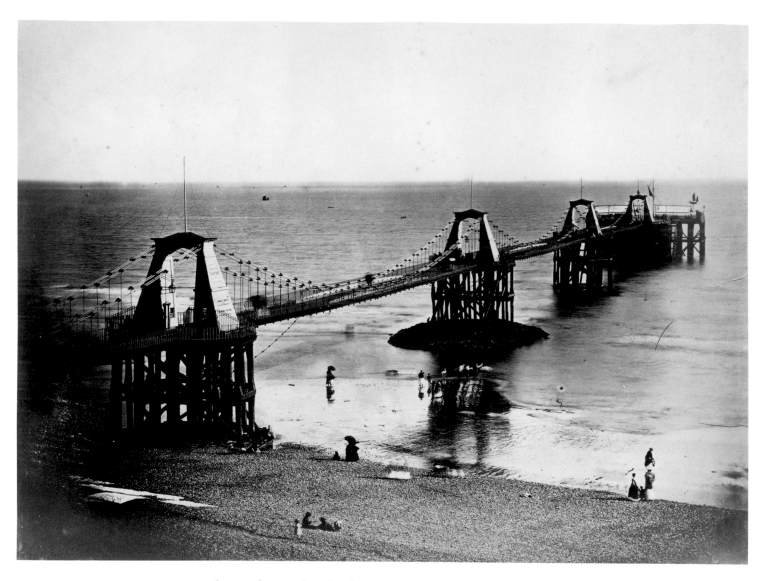

Unknown photographer, the Chain Pier, 1870, albumen print, *199 x 269mm*

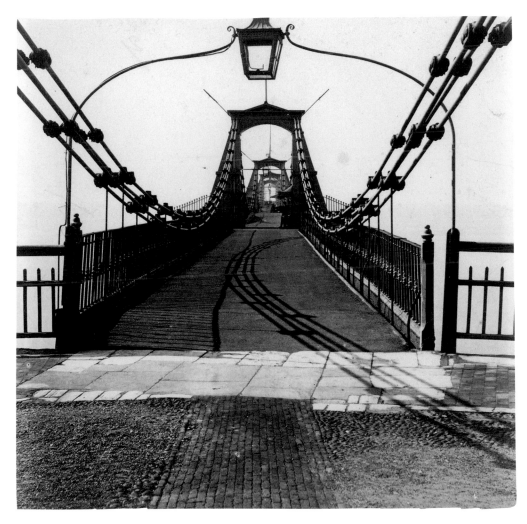

Unknown photographer, the Chain Pier, 1860s, albumen print, *134 x 135mm*

Unknown photographer, the Aquarium, from Marine Parade, probably 1874, albumen print, *215 x 422mm*

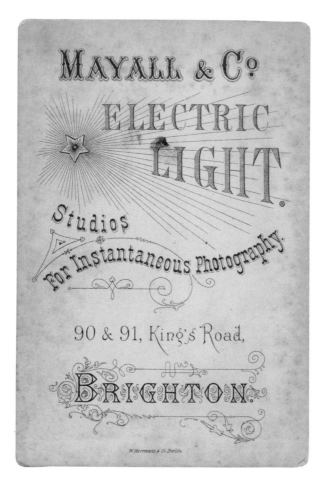

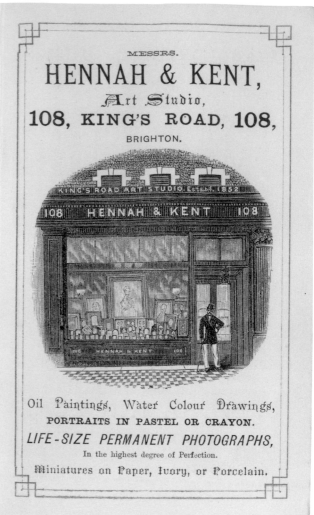

John Jabez Edwin Mayall, announcement of Electric Light Studio facilities, 1880s, reverse of cabinet card

Hennah & Kent, illustrated advertisement from *Page's Brighton Directory*, 1877, *printed area 148 x 85mm*

King's Road, where small, delicate work…is executed with exquisite finish…. M. Lombardi has also a studio in Brighton; he aims more to secure brilliance and vigour in his productions as does also M. Bertin…. Another studio, a few doors from the Old Steyne, deserves also to be mentioned, that of Mr. Donovan, who was, if we mistake not, but recently the manager of M. Boucher.'[3]

To this list might be added the family partnership of W. & A.H. Fry. Their Photographic and Art Galleries, which opened in 1867 at 68 East Street, boasted 'Reception room, dressing rooms, and studio…upon the ground floor, a convenience which cannot fail to be appreciated'.[4] Allen Hastings Fry had learnt his craft with Hennah & Kent. He and his brother Walter published views, and made a speciality of group portraits of every kind – theatre, school, professional, sporting, and so forth. E. Hawkins, whose studios operated from the early 1870s and into the early twentieth century, occupied Hennah & Kent's premises for about a decade from the mid-eighties. She specialised in studio portrait work and made interesting views, including studies of storm damage to the West Pier, and of the sorry remains of the Chain Pier after it was destroyed by a storm in 1896. And credit of a unique order should go to the

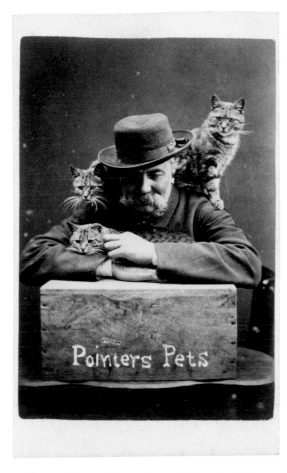

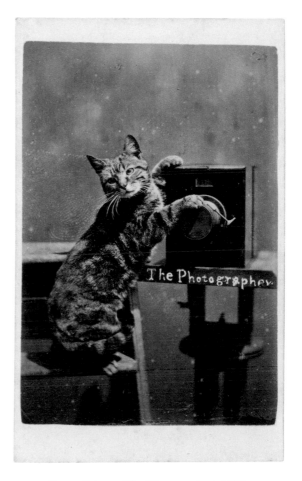

Harry Pointer, self portrait, probably early 1870s,
albumen print *carte de visite*

Harry Pointer, 'The Photographer', 1870s,
albumen print *carte de visite*

remarkable Harry Pointer for exerting a seemingly hypnotic spell on the cats who posed for him in every conceivable guise. 'An eminent photographer,' we are told, 'has produced a series of *cartes* that cannot fail to be very popular.… It was a good idea so to train a number of cats as to make them excellent, attentive, and obedient "sitters"…it seems as if each knew precisely what he wanted, is gentle or fierce, or listless or eager, or docile or angry, according to the character depicted.'[5] More than one hundred images were published.[6]

John Jabez Edwin Mayall's Brighton operation was certainly impressive, ideally located just to the east of

the Grand Hotel, and boasting at least four separate studios. One was on the first floor, 'a spacious drawing room with two windows, with couch, table and mantelpiece within eight or ten feet from the light', and 'upstairs …the ordinary studios. They are three in number…the cameras…all fixed upon heavy cast-iron stands. Two of the studios are built parallel, and only divided from one another by a heavy tapestry curtain. In the one you have a westerly light; lift the curtain and walk into the adjoining room, and the light is easterly.'[7] Mayall, the pioneer whose magnificent daguerreotypes had attracted the personal appreciation of Prince Albert at the Great Exhibition of 1851, maintained a genuine interest in

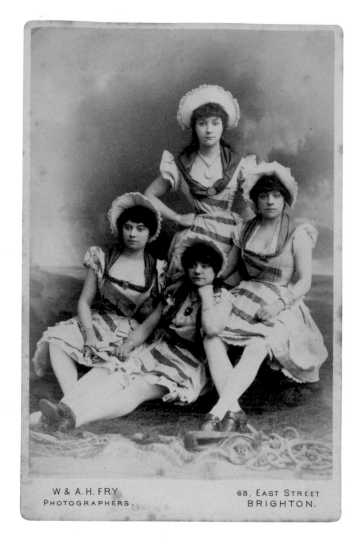

W & A.H. FRY
Photographers.

68, East Street
BRIGHTON.

W. & A.H. Fry, pantomime group, 1880s,
albumen print mounted as cabinet card

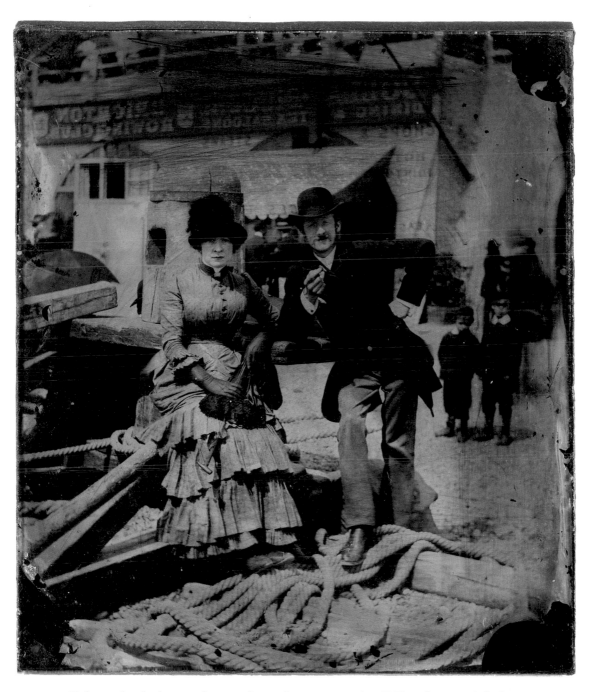

Unknown beach photographer, couple posed on a capstan, circa 1880, ambrotype, *sixth plate*

George Washington Wilson & Co., beach vista looking towards the West Pier, 1880s, albumen print, *190 x 292mm*

the applications of new techniques. He presented a paper on the permanent carbon process to the British Association when they met in Brighton in 1872.[8] Mayall, the businessman, recognised the value of 'Imperishable Portraits in Carbon', just as he saw the potential of promoting his 'Electric Light Studios for Instantaneous Photography'.[9] He had become something of a celebrity and a recognised brand, and was now a photographic entrepreneur, lending his name and reputation to studios in London and Brighton, much of the work being undertaken by his sons, studio managers and junior staff.

In the progress of photography as a flourishing commercial enterprise, Mayall's portrait activities echo those of a number of high-profile topographical photographers who built successful businesses dedicated to the large-scale manufacture and wide distribution of photographs of every corner of Britain. Such images enjoyed enormous popularity, and were bought enthusiastically, mounted into albums as souvenirs of places visited, or to give shape to as yet unrealised journeys. Brighton, with its busy and colourful promenades and beaches, and its distinctive architecture, provided fine subject matter, while the large numbers of visitors ensured a constant popular market.

Among the first visiting commercial photographers to make worthwhile photographs of the town was Valentine Blanchard. His 1863 series of stereoscopic 'Instantaneous sea and land views' well capture the bustle and curiosities of the beach and include 'several very fine sky and water

James Valentine & Co., the fishing fleet, 1880s, albumen print, *185 x 280mm*

studies taken in Mr. Blanchard's best style'.[10] The national firms established by Francis Frith in Reigate, James Valentine in Dundee, and George Washington Wilson in Aberdeen published extended series of views of Brighton and Hove, principally in the 1870s and 1880s. The faster and more practical dry emulsions now becoming available enabled the journeymen photographers employed by these large firms to effectively capture people in movement using medium to large format plates. The results survive as a valuable tapestry of architectural detail and of scenes of daily life.

Thomas Donovan's commitment would seem to have been more personal. After working in the studio of M. Boucher, he founded his own business in the late 1870s at 1 St James Street, close to the Old Steine.

Though not born in Brighton, he became closely involved with the life of the town, and by the 1890s was its most prominent and respected photographer. He became the photographer of choice for prestigious civic occasions. 'A new park was opened in Kemp Town,' he wrote to his son Harry in August 1892, 'and I had to photograph the Mayor and Corporation in big groups.'[11] 'Mr. Donovan,' wrote a local commentator, 'now has such a reputation as an artist and photographer that his handsome studios in St. James Street have become a leading centre of attraction to visitors. Indeed, the handsome show front of the premises, with its fine display of beautifully mounted photographs, etc., forms in itself a small exhibition of art work of the highest class, and one can rarely inspect the window without noting that every phase of the ever changing life of Brighton is watched by Mr. Donovan,

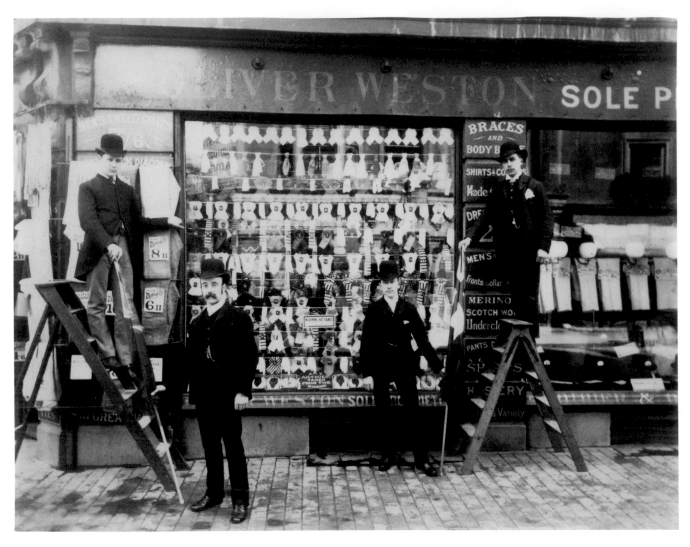

Unknown photographer, shop front of Oliver Weston, North Road, 1880s, albumen print, *168 x 218mm*

Francis Frith & Co., the promenade looking west towards the Aquarium, 1880s,
albumen print, *139 x 174mm*

and caught "on the wing" by his busy camera.'[12] He enjoyed the use of 'all the most improved modern lenses, cameras, appliances, and accessories...to ensure the perfection of the work...there are also work-rooms for retouching, painting, finishing, and mounting the pictures, only first class artists and workpeople being employed, and the whole of the work being under the general supervision of Mr. Donovan, who gives a special personal supervision to the posing of the sitters and the general operating work in the studio. Mr. Donovan, however is ably assisted by his two sons and his daughter, and an efficient staff of other assistants, his eldest son, Mr. C[harles]. Donovan...taking special charge of the outdoor work, in which he is a specialist of acknowledged ability...such success in illustrating scenes of local life as we have attained must be shared in very large proportion with Messrs. Donovan and Son.'[13]

1. 'British Association. Brighton meeting, 1872', *The British Journal of Photography*, 23 August 1872, p. 400

2. Ibid

3. 'Photography at London-super-Mare', *The Photographic News*, 25 July 1879, p. 349

4. *The Court & Society Review*, 17 January 1886

5. *The Art-Journal*, London, 1876, p. 374

6. Printed text on verso of *carte*, March 1872

7. H. Baden Pritchard, *The Photographic Studios of Europe*, London, 1882, pp. 127–31

8. 'Carbon Printing', *The Photographic News*, 30 August 1872, pp. 413–17

9. Printed texts on verso of cabinet cards

10. 'Stereographs: Instantaneous sea and land views at Brighton: Photographed by Valentine Blanchard, London: C.E. Elliott, Aldermanbury Postern.', *The British Journal of Photography*, 1 January 1864, p. 18

11. Letter to Harry Donovan, 15 August 1892

12. *Views and Reviews Special Edition. Brighton and Hove*, Brighton, undated, pp. 94–95

13. Ibid

Thomas Donovan, facades in Bartholomew's, opposite the Town Hall, from a sequence taken at short intervals through the late afternoon, 4.20pm, Wednesday 7 July 1897, gelatin silver print, *236 x 290mm*

Thomas Donovan, self-portrait, 1890s, albumen print mounted as cabinet card

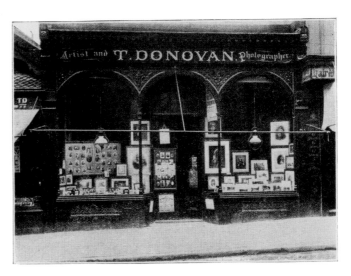

Thomas Donovan, the St James Street studio, 1890s, half-tone illustration, *77 x 101mm*

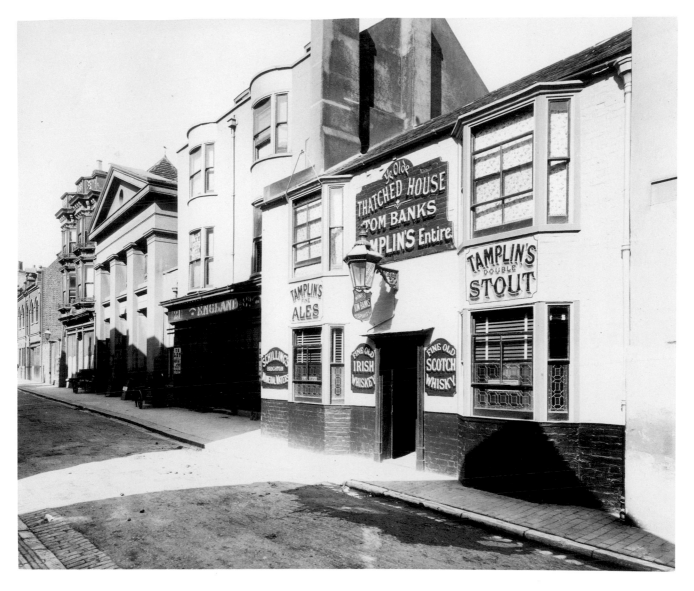

Thomas Donovan, the Thatched House public house, 22 Black Lion Street, 1890s, gelatin silver print, *238 x 281mm*

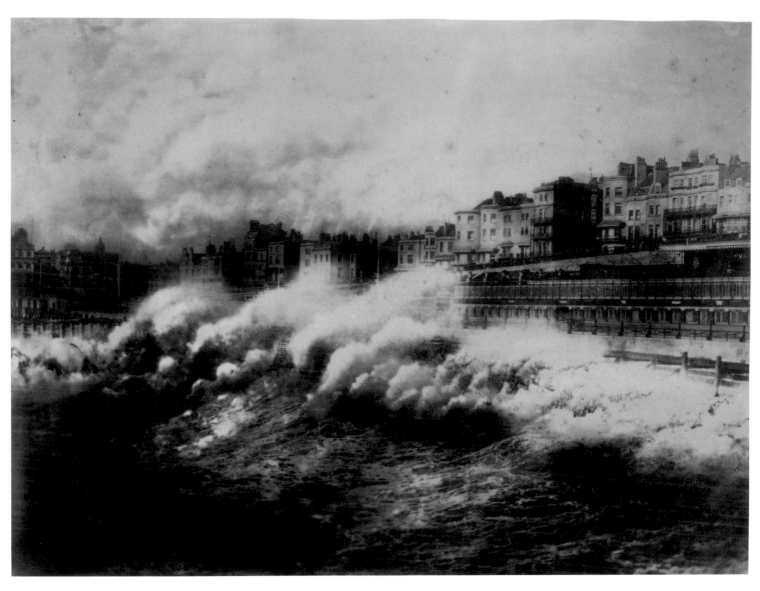

W. Wright, 'Storm at Brighton', from the Chain Pier, 19 October 1891, gelatin silver print, *approx. 410 x 545mm*

THE TURN OF THE CENTURY AND NEW CONCERNS – art and the instant

By the turn of the century, the small Royal spa town in which William Constable had set up as a gentleman photographer offering a prestigious and costly portrait service to a wealthy and privileged circle had grown beyond recognition into a bustling, popular resort. The commercial practise of photography had flourished, for the use of cameras by amateurs was not yet widespread, and residents or visitors wanting a lasting image of themselves or others had no alternative but to turn to a professional, of greater or lesser skill. While Donovan's endeavours represented the more ambitious aspects of professional practise, *cartes de visite*, cabinet cards, ambrotypes and tintypes had become the stock-in-trade of numerous more run-of-the-mill commercial portrait operators. Their output comprises a mostly stiff and self-conscious gallery of formal studio presentations of the self, and artless, yet intriguing, enigmatic poses and groupings on beach and promenade – the family outing, a mother and her children, a couple, friends, a young woman, posed perhaps for her beau. Every image is a fragment of an anecdote, a glimpse of the flow of life itself – sometimes all the more forceful for the fact that no artistic ambition has intruded in the moment of interface between subject and posterity. The photograph had become a democratic and seemingly dispassionate recording tool, won by the populace from the claims of artists and of the gentry.

Within the literature of photography and in other discussion forums, issues of the status of the medium were being thrown into question as they had been half a century before. Art or science? Creative medium or purely practical commercial agency? How should photography be perceived? Professionals had consistently staked their claim as artists. Brighton's studio photographers, from Hennah & Kent and George Ruff in the 1850s to Thomas Donovan in the 1890s, had regularly emphasised their artistic credentials. In the face of ever-greater commercialisation in the manufacture and distribution of photographic materials, and with the more populist

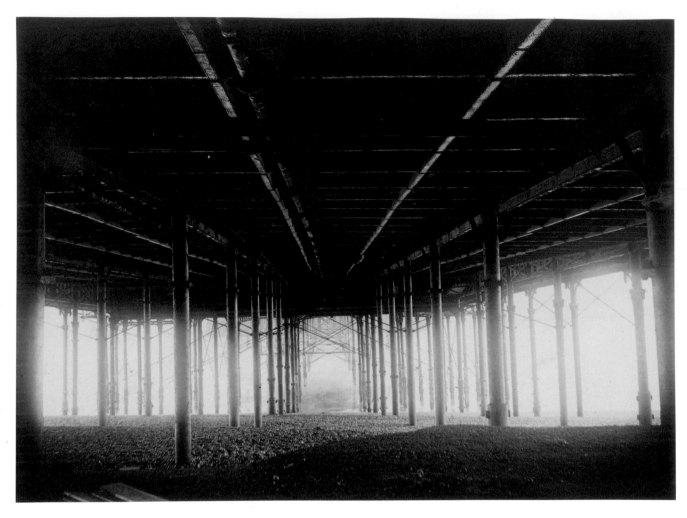

W.H. Schwartz, under the West Pier, circa 1900, gelatin silver print, *154 x 209mm*

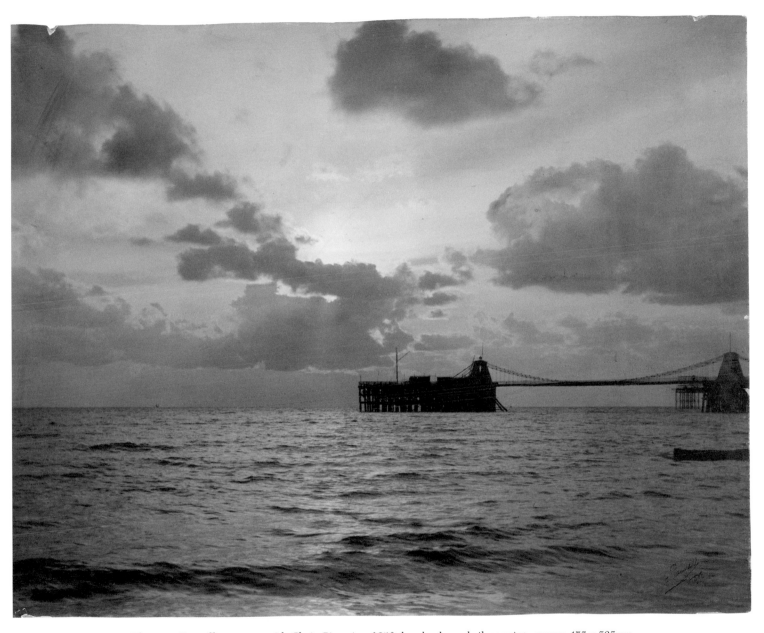

Ebenezer Pannell, seascape with Chain Pier, circa 1890, hand coloured silver print, *approx. 475 x 595mm*

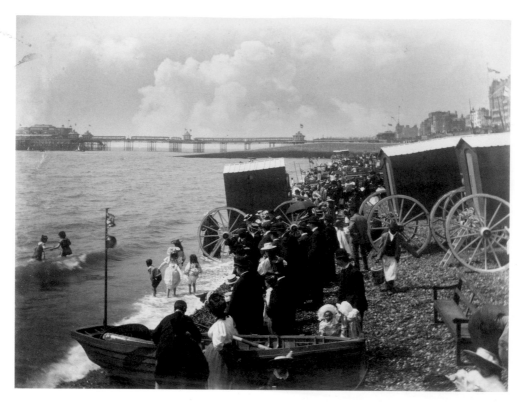

Burt Sharp, at the water's edge, looking west, early 1890s, gelatin silver print, *213 x 281mm*

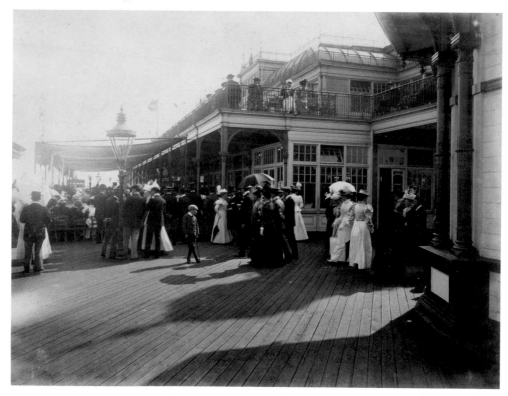

Burt Sharp, on the West Pier, early 1890s, gelatin silver print, *213 x 280mm*

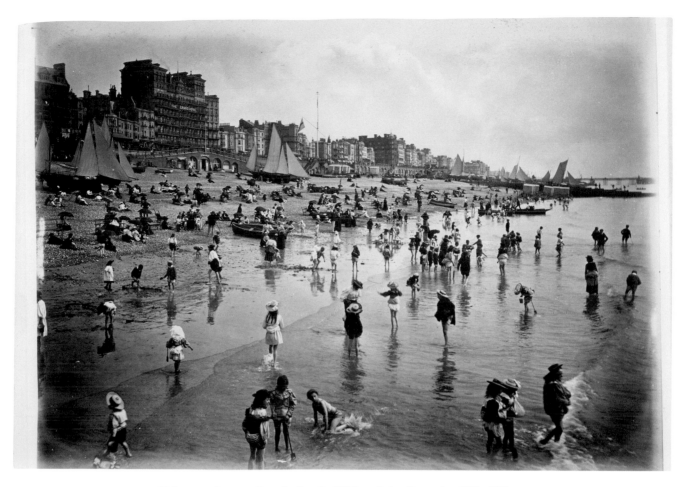

Unknown photographer, the beach, 1890s, gelatin silver print, *215 x 309mm*

emphasis of so many of the photographs themselves, the 1890s witnessed an emphatic reaction to the threat of debasement to which the medium seemed vulnerable. The consequence was an aesthetic polarisation within both amateur and professional practise.

Photographer Ebenezer Pannell, active from the late 1880s, made an image of a dramatic sea and sky with the Chain Pier on the horizon, and printed it to a very large format, heightening the theatrical effect with washes of hand colouring. He is staking a claim to the picture's status as a work of artistic expression. A contemporaneous set of pictures, preserved on the mounts of photographer Burt Sharp, active from his West Street premises from the mid-1880s, capture the spontaneous choreography of the crowds animating West Pier and water's edge, and

other busy scenes on the promenade. The contemplative and considered marks a contrast with the compelling authority of the frozen moment.

Amateurs dedicated to photography as a creative art came together in Britain and internationally to defend the high aesthetic status of their chosen medium. Local and national clubs and societies fostered the idea of photography as a noble artistic calling. Meanwhile, the arrival on the market of a new generation of cameras, promoted for amateur use by Kodak, opened an alternative avenue and aesthetic, that of the moment seized, the immediate and personal document, the instant captured from life. In Brighton, the opposing character of these two approaches is well illustrated in the contrast of two dedicated amateurs, Charles Job and George Ruff Junior.

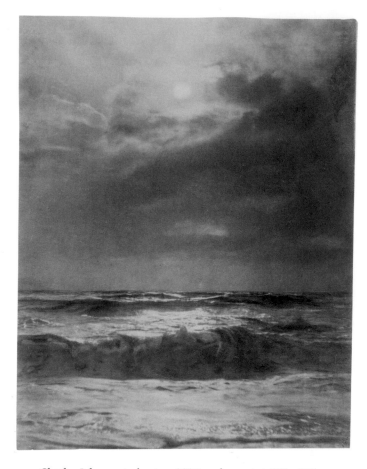

Charles Job, sea study, circa 1900, carbon print, *278 x 217mm*

Charles Job was a successful stockbroker. Born in Surrey, he took up residence in Hove. He was an early member of the Brighton and Hove Camera Club, formed in 1891, and soon became Honorary Treasurer and Vice-President. From 1895 he was a fellow of the Royal Photographic Society. But, most significantly, he was to join the Linked Ring. This society, founded in 1892 and anticipated only by the Vienna Camera Club the previous year, was an early focus in Britain for the development, expression and exchange of ideas in the new 'secessionist' movement seeking an independent artistic voice for photography.

Reviewing Job's achievement in 1907, and referring specifically to fine prints shown at the Hove Camera Club, a commentator claims that 'The gems of these exhibitions are very different to the great bulk of the ordinary amateur and professional work which is printed off, fixed and mounted directly the plates used have been developed. They are almost as far above them as an Academy picture is above the rough charcoal sketch of its conception. And it does not require an intelligence susceptible to artistic impressions to appreciate their superior *genre*. Probably the finest examples of this lofty type of photographic art ever produced in Brighton have been evolved by Mr. Charles Job...whose name is known and whose beautiful work is honoured far and wide throughout the camera world.... He is undoubtedly one of the men who have helped win for [photography] a definite art plane of its own – to compel a grudging, and therefore all the more significant recognition of its artistic status from the prejudiced critics and other

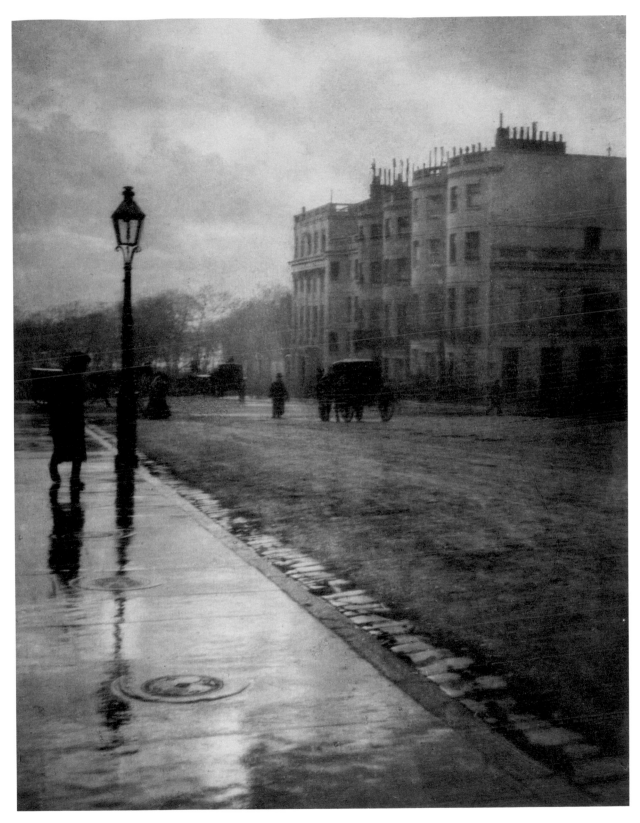

Charles Job, Brunswick Place in the rain, circa 1900, carbon print, *351 x 270mm*

George Ruff Junior, self-portrait with Dorothy shortly after
her adoption in October 1903, silver print, *116 x 93mm*

sticklers for tradition in the "paint and pigment" camp.'[1]
Job experimented with techniques, ultimately favouring
the carbon print, using the process, not like Mayall for
permanence, but for the soft, painterly effects that he
could achieve with it on mat, textured papers. In his study
of Brunswick Place in the rain he succeeds masterfully
in creating an impressionist picture by photographic
means. Job has turned a street scene near his home into
an atmospheric image of soft, subdued light, melting
shapes and tones, a photographic 'nocturne'.

George Ruff Junior had been drawn into the photographic
web from an early age. As an infant, he was portrayed
by his father within a family tableau ambrotype. He was
the subject of various other portraits, notably an image
in which we see him, smartly dressed in stovepipe hat,
in the doorway of the prospering family studio and
shop. When his father died in August 1903, the son
demonstrated his filial respect, and his recognition of
his father's creativity in a *memento mori* still life. A cabinet
portrait of his elderly father is set among a plate camera
and dark slide, a palette and brushes and a chronometer,

all resting on a bound volume, *Art & Letters*. The son's
destiny as a photographer was in the process of finding
its fulfilment. Slim and elegant, like his father, and
with a neat beard, George Ruff Junior posed frequently
for the camera as an adult. We see a man exploring
his identity. There appears to be a concentration, an
intensity of expression in his face, and a suggestion of
sensitivity in his long, fine fingers.

Ruff's imagination was captured by the potential of the
new, fast, orthochromatic emulsion dry plates and easy-
to-use cameras that heralded the era of 'snapshot'
photography. Living from the income generated by his
father's investments, Ruff was free to pursue his interests.
That he was already active as a photographer around
the turn of the century is confirmed by an image of a
newspaper vendor on the promenade with his dramatic
printed bill, 'Death of the Queen'. Ruff had lost two
wives and their babies in childbirth. In the autumn
following his father's death, he and his third wife, Mary,
responded to an advertisement in a newspaper and
adopted a daughter, Dorothy. He started a systematic

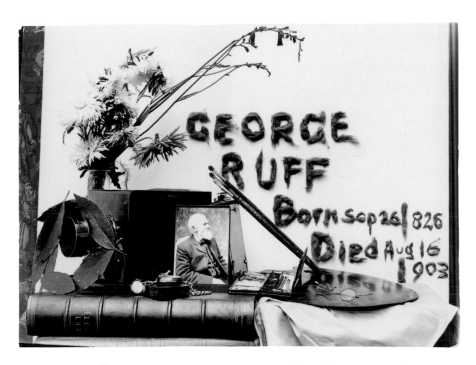

George Ruff Junior, *memento mori*, August 1903, gelatin silver print, *74 x 99mm*

photo-document of her life.[2] Mary later bore him a son, Aubrey, in 1907, and it was he who carefully preserved till his death in the early 1970s key elements of the photographic work of both his father and grandfather.

Ruff purchased prepared negatives, 'Warwick Plates' manufactured by The Warwick Dry Plate Co., 'Barnet' plates 'for studio or field' made by Elliott & Son, or other plates from the Imperial Dry Plate Co., London. A meticulously kept Exposure Note Book records a trip 'Tuesday March 22nd 1904. To London to buy… Newman & Guardia's focal plane camera "Cyclops" ¼ plate £10-10-0', and details his first exposure with the new camera five days later. There followed a few years of intensive activity, with our photographer busy through all seasons, though making his most frequent sorties in the summer months. He would travel to other locations in Sussex, but worked most consistently in Brighton.

His favoured subject matter was the varied activity of people on the beach, the fishermen, traders, entertainers, but particularly children, for whom he showed a natural affinity. He started to compose a precious album of pictures of Dorothy in October 1903, and cast her as the central figure in many of his street and beach snapshots. Working fast to preserve a sense of spontaneity, he made pictures of considerable vitality and also succeeded intuitively in giving his compositions a tight formal structure. Scenes of domestic life and a range of self-portraits preserve a vital extra facet. These images add a highly personal dimension to the body of work and re-enforce the value of George Ruff Junior's photographic legacy. Ruff's oeuvre carries on a tradition of depiction established by his father with brush and camera in the 1850s and yet manages emphatically to point a fresh path, a new, independent aesthetic for the straight photograph as the prime recording medium of the twentieth century.

1. 'Mr. Chas. Job and his Art. A noted Brighton amateur photographer', *The Brighton Review*, 1907
2. Biographical and other information from author's conversation with Dorothy Ruff, circa 1975

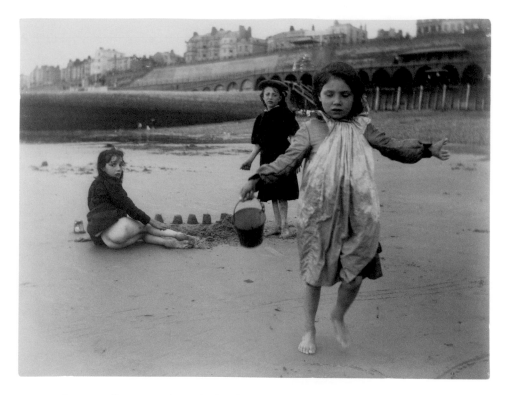

George Ruff Junior, girls on the beach, circa 1905, gelatin silver print, *74 x 97mm*

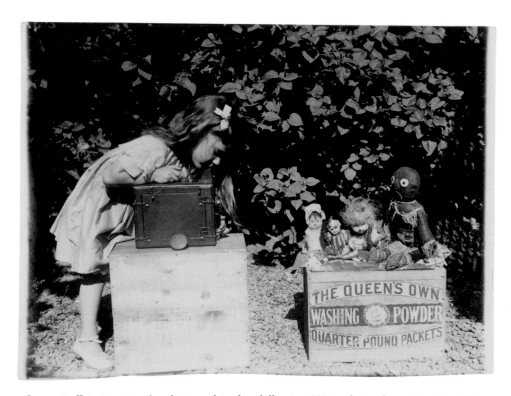

George Ruff Junior, Dorothy photographing her dolls, circa 1905, gelatin silver print, *80 x 107mm*

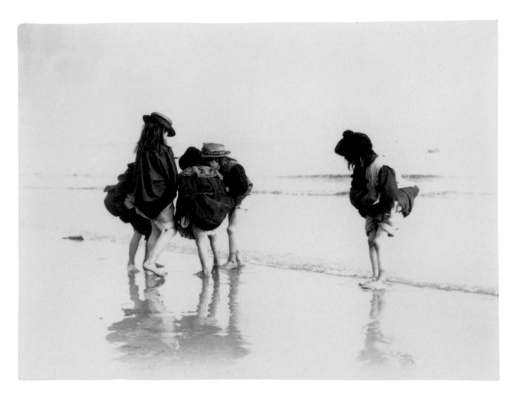

George Ruff Junior, girls paddling, circa 1905, gelatin silver print, *74 x 98mm*

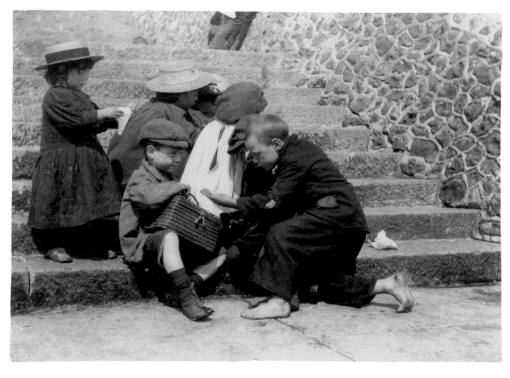

George Ruff Junior, children on the steps of a groyne, circa 1905, gelatin silver print, *71 x 98mm*

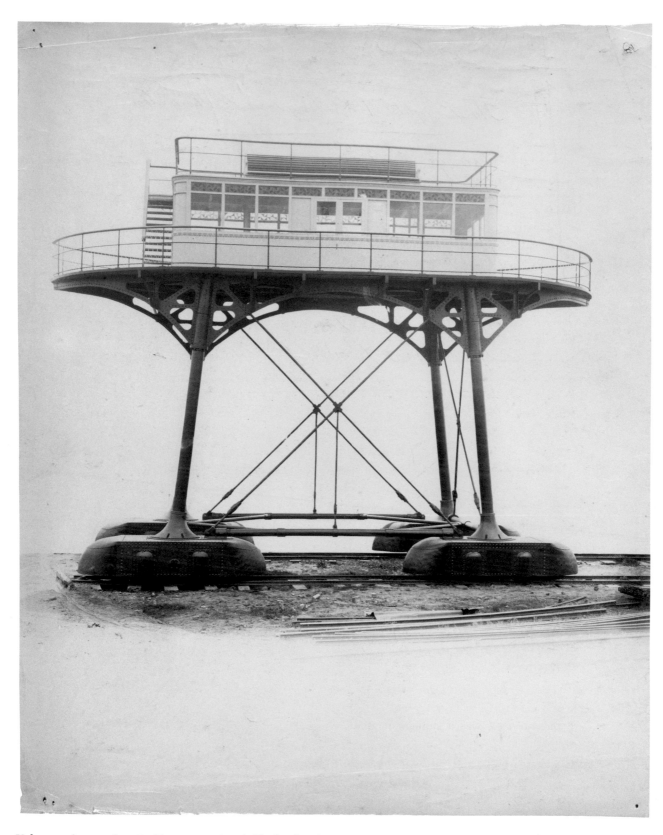

Unknown photographer, 'Daddy Long Legs', probably shortly prior to its inauguration in November 1896, albumen print, *366 x 292mm*

THE NEW CENTURY – reportage and the new vision

The turn of the century was straddled by the short life of one of the most eccentric constructions to grace Brighton's sea front. Engineer-inventor Magnus Volk, who had earlier built a pioneering electric railway along the East Beach, inaugurated in November 1896 an electric excursion vehicle that ran on underwater rails laid parallel to the shore, from the 'Banjo' groyne to Rottingdean. The interior, all deep-buttoned plush banquettes, heavy curtains and potted palms, was High Victorian. The structure itself was a vision of the future, soon nick-named 'Daddy Long Legs' after its curiously anthropomorphic metal stems. Volk's imaginative experiment in engineering – a strange, alien form that calls to mind H.G. Wells's sinister science-fiction inventions in his 1898 *War of the Worlds* – was a subject of great fascination to photographers. Dismantled in 1901, this was not to be the shape of things to come.

The future took a different form. Man took to the skies. In the years after World War I, the rapid development of civil aviation was to provide a novel tool and a fresh vantage point for photographers. In a new spirit of supposedly objective social recording, Britain was surveyed from the air. Brighton and Hove were systematically documented in this way over the next few years. A certain A.W. Wardell of 39 West Street published as post cards a series of

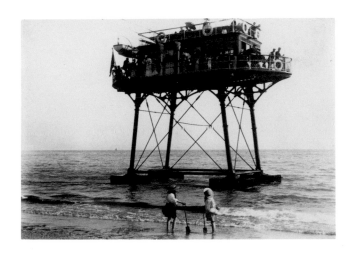

Francis Frith & Co., 'Daddy Long Legs', circa 1900, albumen print, *146 x 204mm*

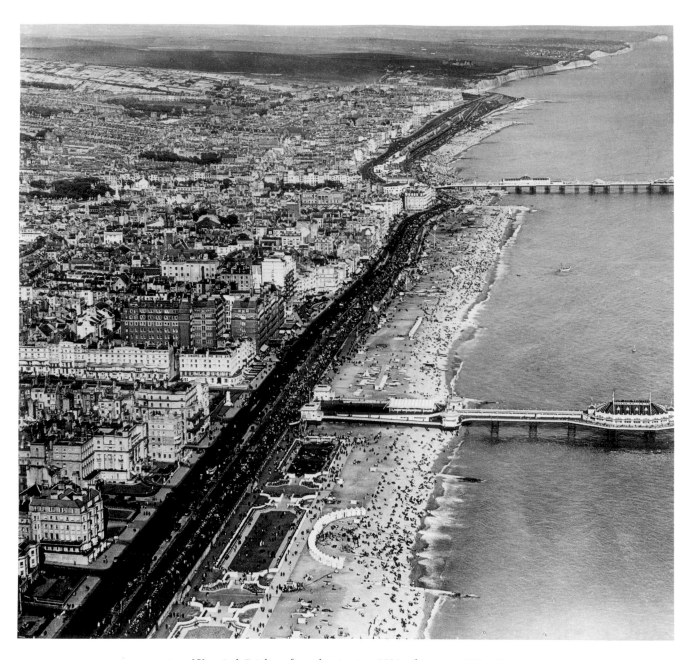

Aerialfilms Ltd, Brighton from the air, circa 1930, silver print, *230 x 247mm*

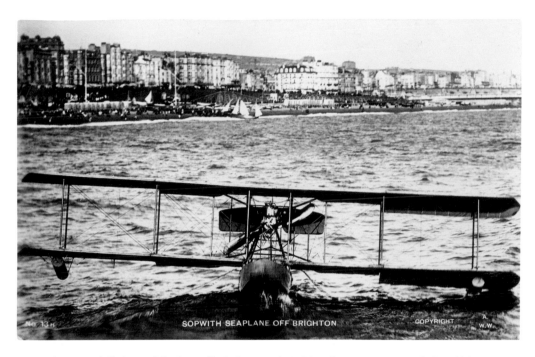

A.W. **Wardell**, Sopwith biplane off Brighton, early 1920s, silver print post card, *87 x 136mm*

aerial studies of the sea front and the urban sprawl that lay behind. Each bore the printed caption 'This is a Real Photograph from an "Avro" Aeroplane'. One has a postmark for the 3rd July 1922 over a stamp bearing the profile of George V. A further extended series of aerial images of Brighton and Hove was made and issued by Aerialfilms Ltd, operating from the London Aerodrome at Hendon. Wardell himself photographed a Sopwith seaplane off Brighton. The contrast of this new mode of transport with the sailboats in the distance marked the advance of technology, and symbolised a changing vision.

Such bird's-eye views clearly show the scale of the town but do not reveal the full realities of narrow, congested streets, poor housing, shabbiness and despondency. For, 'From the turn of the century…the town had sunk into a shabby lethargy,' records a local historian. 'Now,

with almost twenty years gone, Brighton had still to be dragged into the 20th century.'[1] In response to these problems, the Corporation proposed a programme of slum clearance, street widening and urban renewal. The first major stage to be implemented was the widening of two major arteries, Western Road and West Street. Work started in 1926. This project involved a parallel commission from the Corporation to the photographic firm of Deane, Wiles & Millar to undertake a systematic documentation of the streets destined for change. The firm's photo-project extended for over a decade and constitutes an important record of the street-by-street detail and texture of the town.

Deane, Wiles & Millar's remit involved their concentration on architecturally unassuming streets that had all too often been neglected by earlier photographers in

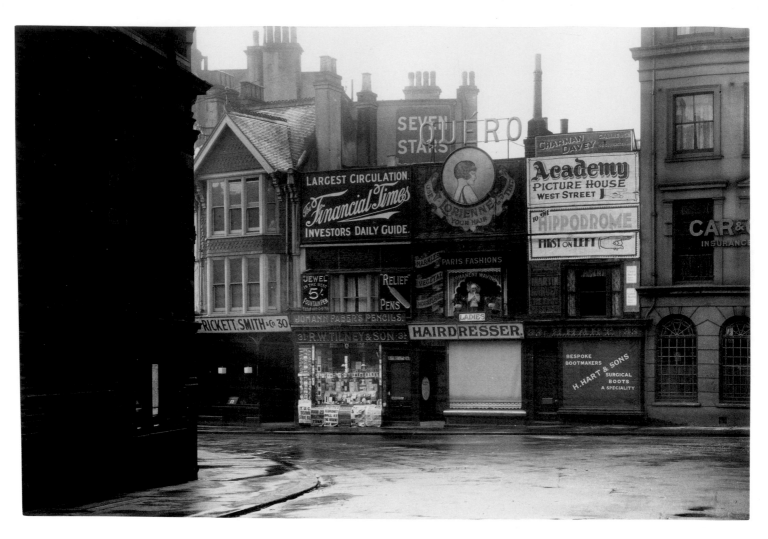

Deane, Wiles & Millar, Duke Street from Ship Street, probably 1927, silver print, *136 x 203mm*

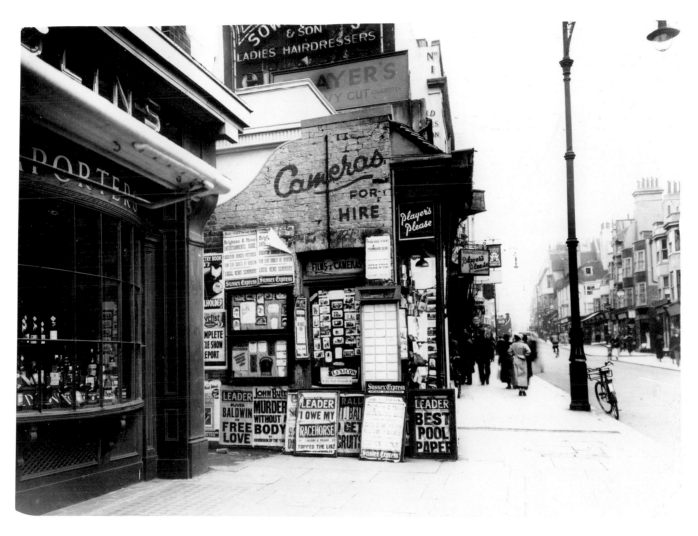

Deane, Wiles & Millar, St James Street, 1932 or later, silver print, *160 x 213mm*

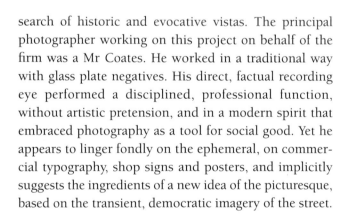

Thomas Wiles, the photographer's premises,
Church Road, Hove, 1920s,
silver print post card, *136 x 85mm*

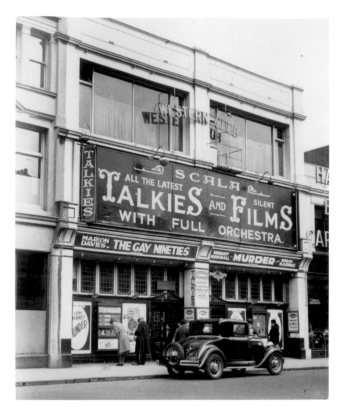

Deane, Wiles & Millar, the Scala cinema, Western Road,
circa 1930, silver print, *260 x 164mm*

search of historic and evocative vistas. The principal photographer working on this project on behalf of the firm was a Mr Coates. He worked in a traditional way with glass plate negatives. His direct, factual recording eye performed a disciplined, professional function, without artistic pretension, and in a modern spirit that embraced photography as a tool for social good. Yet he appears to linger fondly on the ephemeral, on commercial typography, shop signs and posters, and implicitly suggests the ingredients of a new idea of the picturesque, based on the transient, democratic imagery of the street.

Photographer and designer Cecil Beaton also made a series of photographs in Brighton at about this time. His approach was a paean to the past. Beaton used his camera to take visual notes, recording aspects of Brighton's heritage that he might perhaps use as reference within his own historicist design work. Details of the Pavilion, grand terraces, the statue of George IV, a lady in a long

fur coat walking her dog are identified as ingredients for a mythology of Brighton, a photographic revisiting of past glories, rooted in the Regency era, the historic Brighton that was celebrated by Osbert Sitwell and Margaret Barton in their 1935 history of the town.[2]

New photographic realities were meanwhile imposing themselves. From the 1840s till the turn of the century, the photographic print itself had been a primary tool of communication and an object of appreciation. In the years between the two World Wars, this emphasis changed. The print was pressed into service principally as a working tool, as one stage towards the end product, a reproduction within a mass-audience publication. Many professional photographers now reached their public through the medium of the press, and particularly through the illustrated magazines that fast became photography's principal outlet. The birth of photojournalism, most specifically in the Hungarian and German

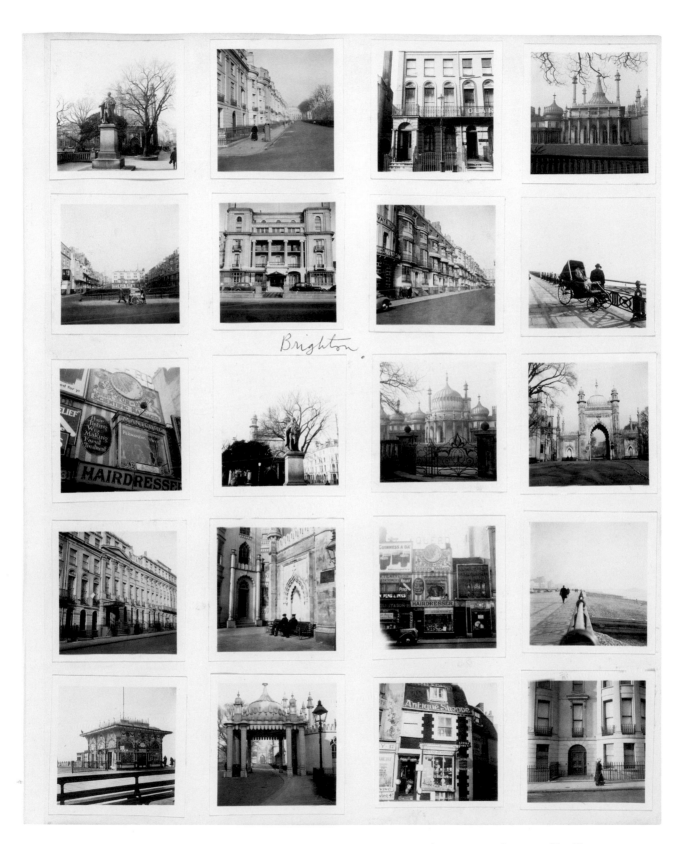

Brighton

Cecil Beaton, album page of contact prints of Brighton scenes, 1930s, silver prints, *each approx. 65 x 60mm*

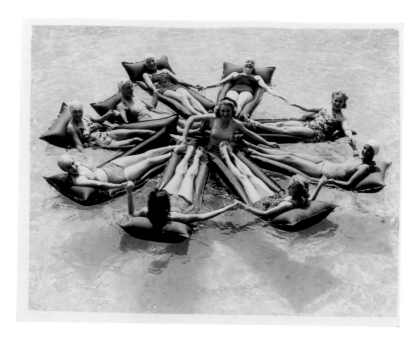

Fox Photos, showgirls in Black Rock swimming pool, 15 June 1939,
silver print, *190 x 240mm*

illustrated press of the 1920s, defined a new role for the photographer as a liberal, populist social anthropologist. This vision, dubbed the '*Neue Sachlichkeit*' or 'new objectivity', had a great impact in Britain in the thirties. New picture agencies flourished, mostly based around Fleet Street, the London centre of news publishing. The 10 x 8in. prints they issued, with the agency stamp and caption label on the reverse, became a ubiquitous press medium until the eventual application of digital technology some sixty years later. Agencies such as Fox Photos, General Photographic Agency, Graphic Photo Union, Keystone Press, Planet News, and Press Pictures Ltd served as the distribution points for the pictures and picture stories of the new photojournalists. Their subject matter was the grit and reality of everyday life.

Bill Brandt's first book, *The English at Home*, published in the spring of 1936, provided an inspired and often lyrical template of the new genre. 'Mr. Bill Brandt is British by birth, but he has spent most of his life abroad, and has thus been able to pick out what makes this country different from others,' explains Raymond Mortimer in his Introduction. 'Mr. Brandt,' he continues, 'shows

himself to be not only an artist but an anthropologist... with the detached curiosity of a man investigating the customs of some remote and unfamiliar tribe.'[3] A double page spread shows, on the left, crowds at the water's edge, framed by the Palace Pier, and, opposite, 'Brighton Belle', a tanned girl, seated on the busy beach, waving, laughing and with a Union Jack stuck jauntily in her paper hat. It is the paper hat described by Graham Greene in *Brighton Rock*, as he evokes 'the noisiest, lowest, cheapest section of Brighton's amusements. Children rushed past...in paper sailor-caps marked "I'm no Angel".'[4] Brandt's picture is in fact staged. The girl is his sister-in-law, Esther. Like Greene, in his compelling account of the seedier aspects of life in Brighton, Brandt has constructed a fiction to illustrate a truth. The raw evidence of Greene's evocation of the tawdry life on front and pier can be found in contemporary press photographs. Greene's central character, the small-time criminal, Pinkie, is surely there among the congestion of figures in a Fox Photos image made on the Palace Pier in the summer of 1936, hidden among 'the holiday crowd...[who] came in by train from Victoria.... Fifty thousand people...down for the day.'[5]

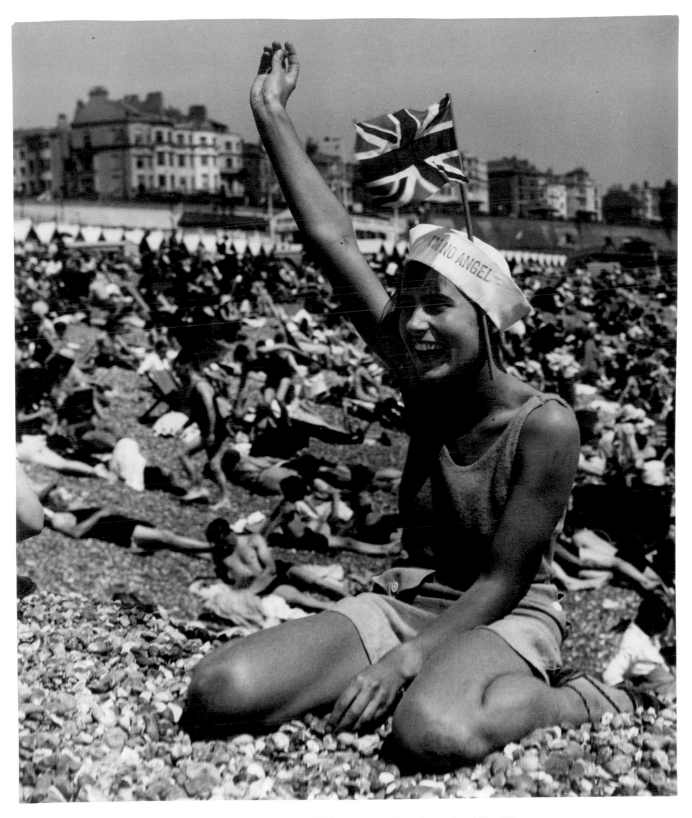

Bill Brandt, 'Brighton Belle', probably summer 1935, silver print, *190 x 160mm*

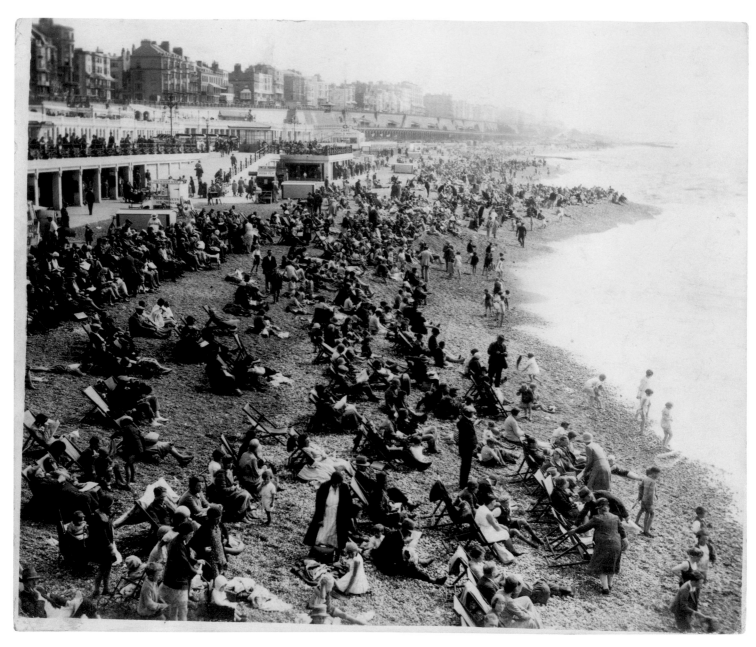

Press Pictures Ltd, the East Beach from the Palace Pier, Saturday 15 August 1931, silver print, *253 x 305mm*

Reggie Speller for Fox Photos, three girls on the beach, 17 June 1933, silver print, *253 x 202mm*

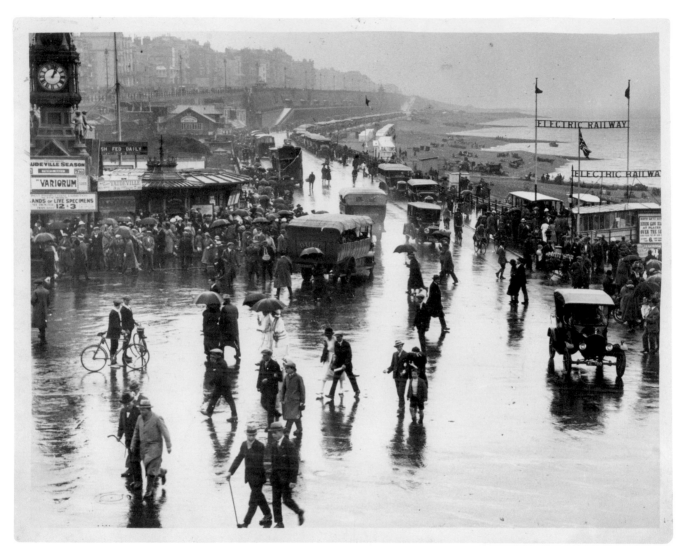

Unknown photographer, August Bank Holiday 1922, silver print, *203 x 255mm*

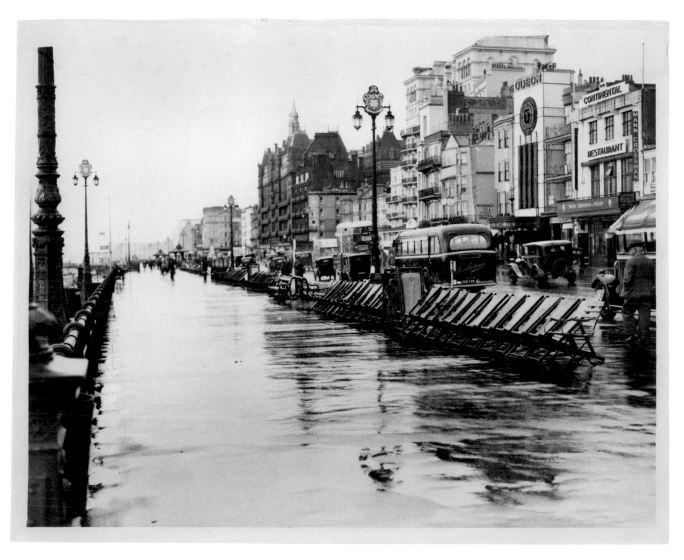

Trampus agency, Paris, King's Road in the rain, 1930s, silver print, *204 x 255mm*

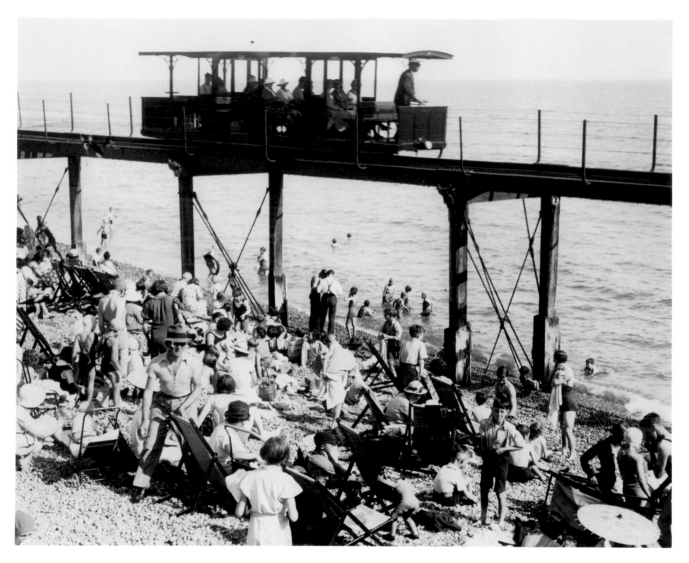

Fox Photos, the East Beach with Volk's Railway passing on raised rails, 25 June 1936, silver print, *205 x 254mm*

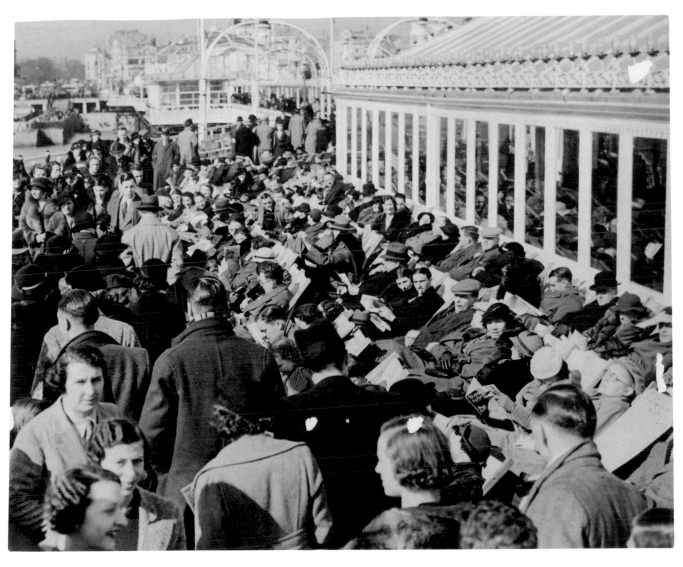

Barry Ward for Fox Photos, crowds on the Palace Pier, 13 April 1936, silver print, *203 x 249mm*

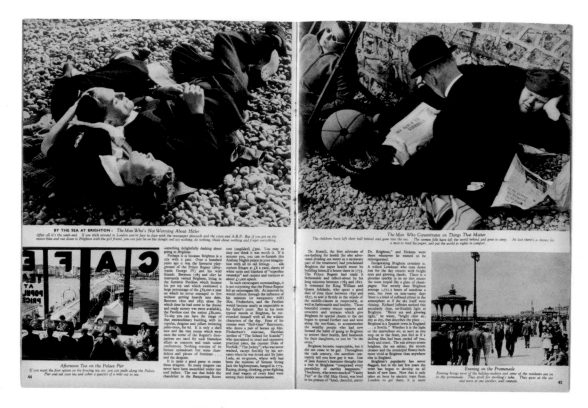

Felix Man, spread from picture story on Brighton, *Picture Post*, 12 August 1939

The new photojournalists were fixing the images of perceived realities. These were published, and their veracity was readily accepted, in the new picture magazines that united the broad populace in a sense of shared identity. The most prominent and successful of these was *Picture Post*, first published in 1938, under the editorship of German émigré Stefan Lorant, founder the previous year of the other great national picture-led magazine, the small-format *Lilliput*. Brandt's work was published regularly in both.

Perhaps the most exemplary photo story on Brighton was that by Felix Man, one of the founding figures of photojournalism in Germany in the late 1920s who, like Lorant, had fled from Nazi fascism. Published by his fellow émigré, Lorant, in *Picture Post* just before the outbreak of World War II, the series of pictures focuses principally on the Brighton experienced by the holiday-makers and day-trippers 'who packed the beach like brightly-coloured sardines, for whom "Brighton" meant the piers, the cafes, the dance halls and the winkle stalls'.[6] The most poignant image is that of a couple, lying together, relaxed, eyes closed, on the pebbles. The caption reads: 'By the sea at Brighton: the man who's not worrying about Hitler'.

1. James S. Gray, *Brighton Between the Wars*, London, 1976, p. viii
2. Osbert Sitwell and Margaret Barton, *Brighton*, London, 1935
3. Bill Brandt, *The English at Home*, London, 1936, p. 4
4. Graham Greene, *Brighton Rock*, London, 1938, part six/2
5. Ibid, part one/1
6. 'Brighton', *Picture Post*, 12 August 1939, pp. 43–49

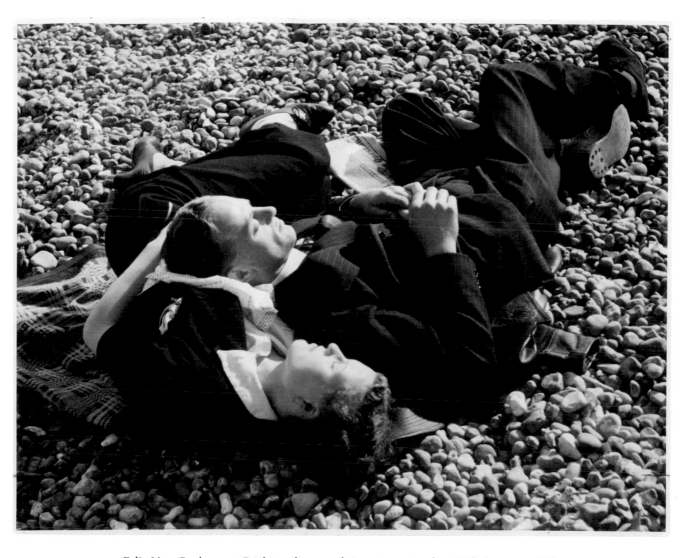

Felix Man, 'By the sea at Brighton: the man who's not worrying about Hitler', summer 1939,
published 12 August 1939, silver print, *200 x 252mm*

Harry Todd for Fox Photos, 'Lighting on the seafront after six years of darkness', 15 September 1945, silver print, *151 x 202mm*

LIGHT AFTER DARKNESS – towards an independent photography

Harry Todd, a staff photographer for Fox Photos, was in Brighton on the 15th September 1945. The war had ended and his task was to illustrate the town coming into its own after years of isolation. He made one image at night, looking west from Marine Parade, the Palace Pier just visible as a silhouette in the distance, a section still missing, removed at the beginning of the war as a precaution against the feared invasion. 'Post-war Brighton,' reads the caption, 'Brighton promenade lights on. Lighting on the sea front after six years of darkness'. Todd had devised an apt visual metaphor.

Bill Brandt's photo story, 'Brighton: the home of the English seaside', was published in *Lilliput* the same month. He shows sunbathers relaxing at the water's edge, a woman in a deck chair on a balcony, another under the pier, and the perennial symbol of continuity, the Royal Pavilion, 'During the Regency…the scene of drunken orgies. Now…occasionally used for mild municipal entertainments'.[1] An image by photographer

Frederick Ramage, issued by Keystone in the spring of 1948, captures the popular mood. Two girls look in a shop window at 'rude post cards all ready for summer visitors to send home, at Brighton'.[2] Below the post cards is a promotional card: 'You can have a wonderful time with *Lilliput*'.

The populist reportage style of picture making associated with *Picture Post* and *Lilliput* enjoyed a continuing role in the post-war years, helping define the national mood. This photojournalistic tradition attracted new talents, both native and foreign. One of the foremost among them was Thurston Hopkins, who established himself as one of the fresh young eyes at *Picture Post*. An image of the sea front under snow shows a bleak and deserted territory. It was made by Hopkins while pursuing a story about a prisoner on leave, eventually published on the 2nd May 1953, though this particular picture was not used. Hopkins took 'the rather unpopular view – among photographers – that words and pictures need

Bill Brandt, on the beach in front of the Grand Hotel, published in *Lilliput*, September 1945, silver print, *229 x 194mm*

Frederick Ramage for Keystone, 'Rude post cards all ready for summer visitors to send home, at Brighton',
8 March 1948, silver print, 207 x 253mm

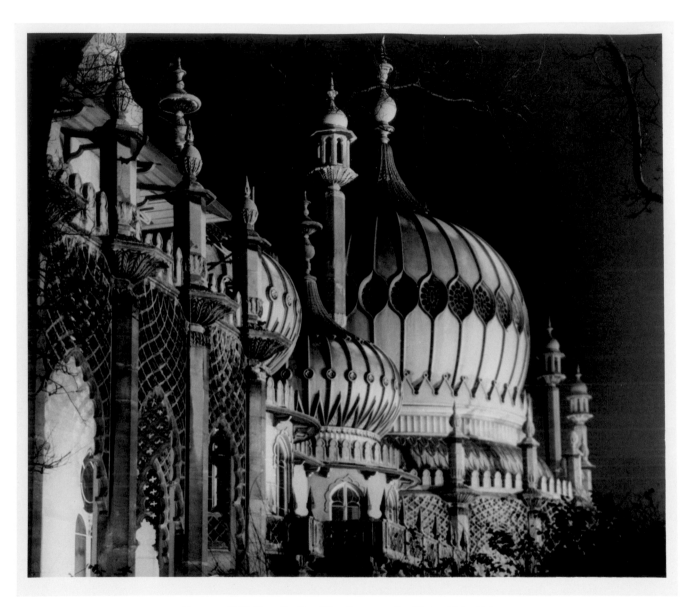

Donovan E.H. Box, the Royal Pavilion at night, 1950s, *256 x 296mm*

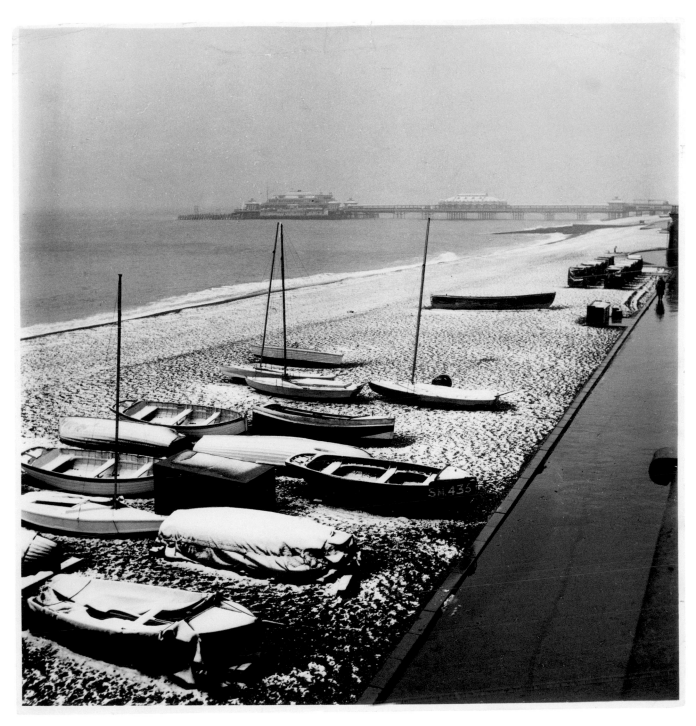

Thurston Hopkins, the sea front after snow, early 1953, silver print, *204 x 197mm*

Stephen Glass, image from a story on people asleep, circa 1950, silver print, *165 x 220mm*

one another',[3] and he worked with the magazine context in mind, words and photographs coming together to tell a story. Characteristically he was accompanied on this Brighton project by a writer, Hilde Marchant.[4]

Stephen Glass and his brother, Zoltan, Hungarian-born émigrés who left Berlin just before the war, were characteristic of the central European diaspora that so enriched the British creative and cultural community. They brought an outsider's eye to the British way of life. Based in London, Stephen was attracted to Brighton where he made various pictures including a series on the theme of people asleep.

One photographer to whom all photojournalists owed respect was the Frenchman Henri Cartier-Bresson. Working swiftly and discreetly with a 35mm Leica, he demonstrated an intuitive mastery in combining spontaneity, a profound humanism and a sure compositional sense. A trip to Brighton in the early fifties has left us an indelible image of a girl in an amusement arcade, her gaze sensuously engaged with Cartier-Bresson's camera.

The post-war years were not Brighton's finest hour. The appealing images of popular beach amusements belie the hardships, the rationing, the bomb damage and temporary housing, and the financial difficulties that were the reality of many people's lives. The years of affluence were yet to come. The fifties were years of sordid scandal. Simmering rumours of widespread police corruption and organised crime involving gambling, drinking clubs and call-girl rackets came to a head in the indictment of Brighton's Chief Constable in 1958. This was the shabby Brighton in which our newly married couple, photographed so poignantly on the promenade just after the war, were now struggling to make ends meet with two small children. He was working in the pharmaceutical department of a local branch of Boots; she took up teaching once the children were of school

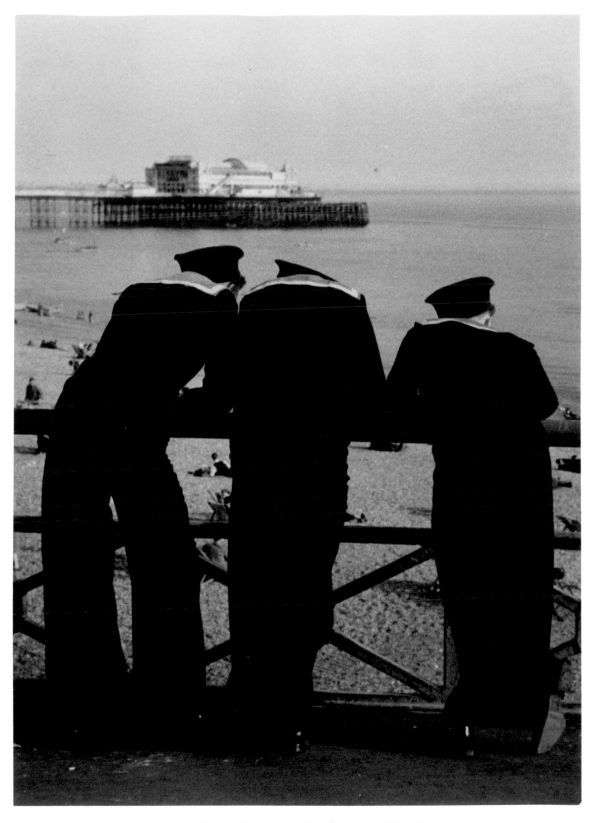

Stephen Glass, sailors, circa 1950, silver print, *196 x 140mm*

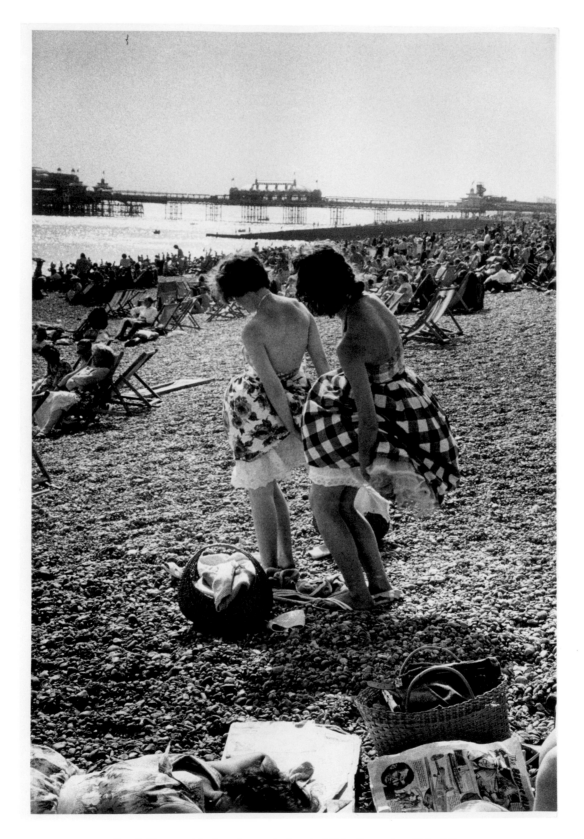

Frank Horvat, girls changing on the beach, 1960, silver print, *306 x 208mm*

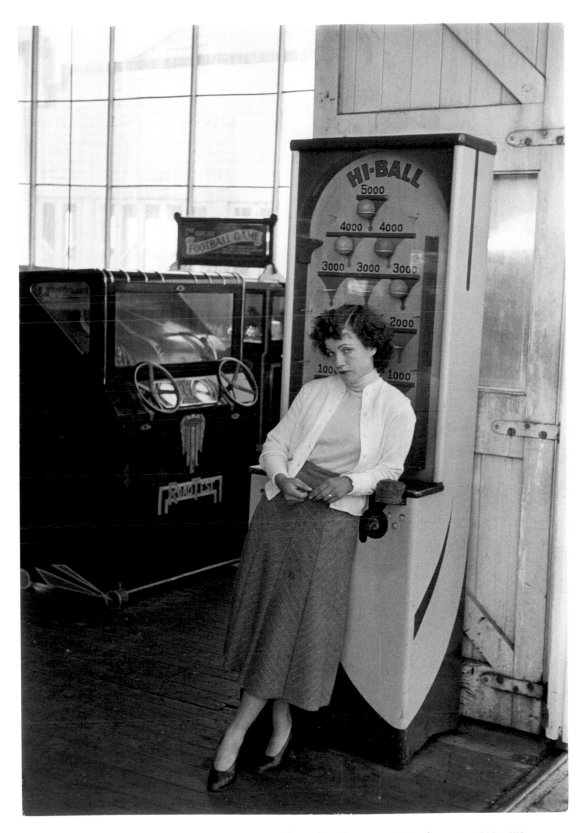

Henri Cartier-Bresson, girl in an amusement arcade on the Palace Pier, 1953, silver print, *249 x 171mm*

Allen Bignell, study on a pier, circa 1960,
silver print, *346 x 245mm*

age. They lived first in a semi-basement in Clarence Square, then briefly in Ship Street before moving in the early fifties to a larger flat off the Ditchling Road. Photographs were not a particular priority to them, yet, like most people, they accumulated a random mix of photographic souvenirs, black and white mementoes of the progress of family life.

The fifties witnessed a gradual shift in emphasis in British photography and photojournalism. *Picture Post* published its last issue in 1957. *Lilliput* ceased publication in 1960. Their approach, in the recollection of editor Mark Boxer 'was linked irretrievably with deprivation and the war'.[5] The move was towards a more individual and creative expression, freed from the constraints of editors and of commercial commissions. Certain photographers identified the need to explore compositional questions more fully, and to develop a more personal perspective within the prevalent tradition of humanist social observation. They were concerned with content, but also with the formal issues implicit in the complex dynamics of photographic picture making.

Aesthetic issues are clearly central to the elegantly and cleverly constructed study under the Palace Pier made in 1957 by London architect-designer Alan Irvine and described by a reviewer when exhibited the following year as 'I think the most successful.... The unseen rain, the infinite perspective, the wet pebbles, the waiting people, the contrasting structures of pier and bicycle, the disconnected chain, a moment is seized and recorded and satisfies completely.'[6] Aesthetic exploration similarly characterises the graphically structured studies of solids and shadows made and exhibited between the late 1950s and the late 1960s by local amateur Allen Bignell.

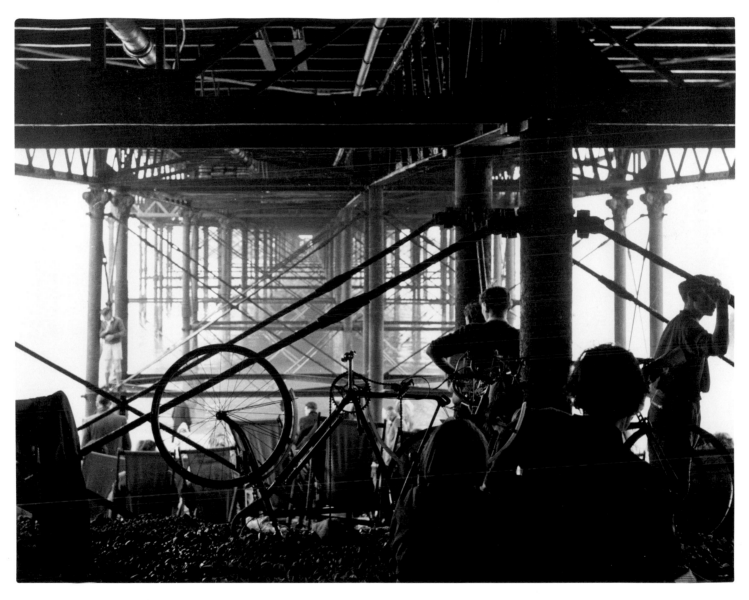

Alan Irvine, under the Palace Pier, 1957, silver print, *195 x 247mm*

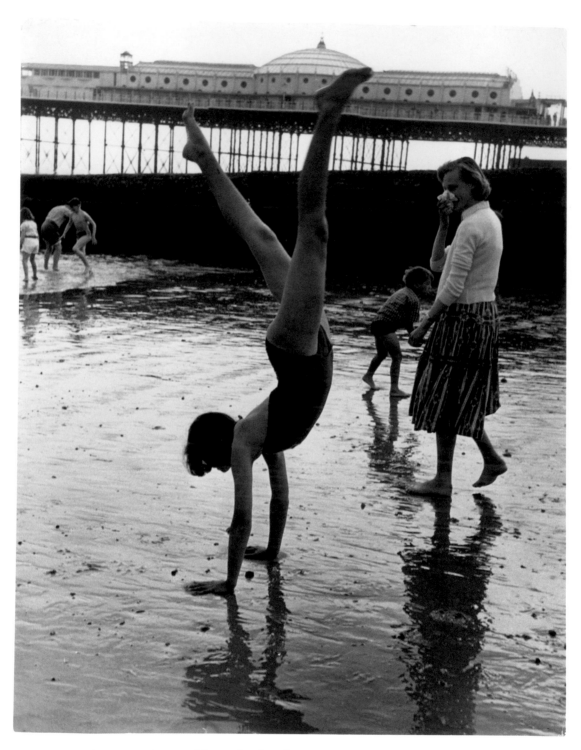

Roger Mayne, girl doing a handstand, June 1957, silver print, *238 x 183mm*

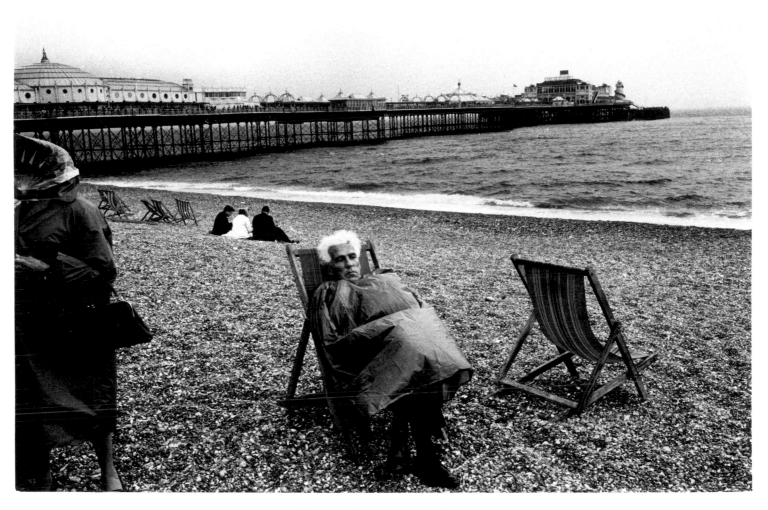

Tony Ray-Jones, solitary figure in a deck chair, 1967, silver print, *image 175 x 264mm*

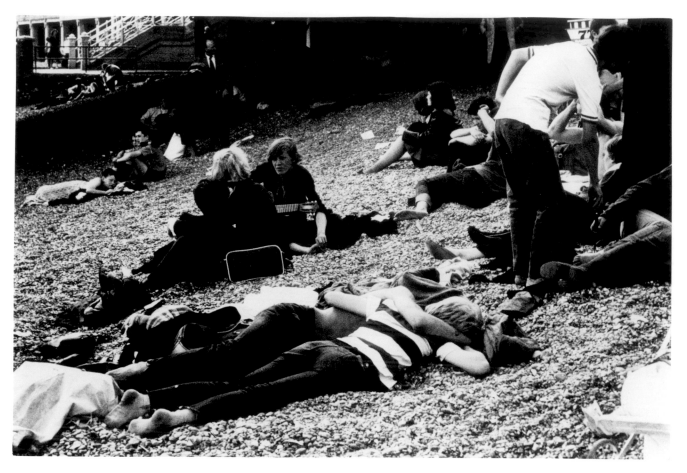

Roger Mayne, figures on the beach, 1964, silver print, *169 x 252mm*

Photographer Roger Mayne is most closely associated with his vibrant and dynamic images of street life in London. He was always concerned with the successful resolution of formal questions and their balance with the inherent energy of the medium. Mayne made a series of photographs on Brighton beach in June 1957 and discusses them in a 1960 *Amateur Photographer*. He reveals his concern with issues of tone, contrast and image structure, yet also emphasises the virtues of chance and the spontaneous. 'The photograph of the girl standing on her hands was not posed,' he explains.

'I saw her doing this a couple of times and rushed in to photograph. The pier in the background is unfortunate, but the figure is good enough to carry the picture. I think one should always go for the positive qualities when taking or judging a picture; it is inhibiting always to be correct – also, times will come when the accidental will help the picture.'[7]

A defining personality in the progress towards an independent British photography was the gifted, mercurial young Tony Ray-Jones. He injected into the British

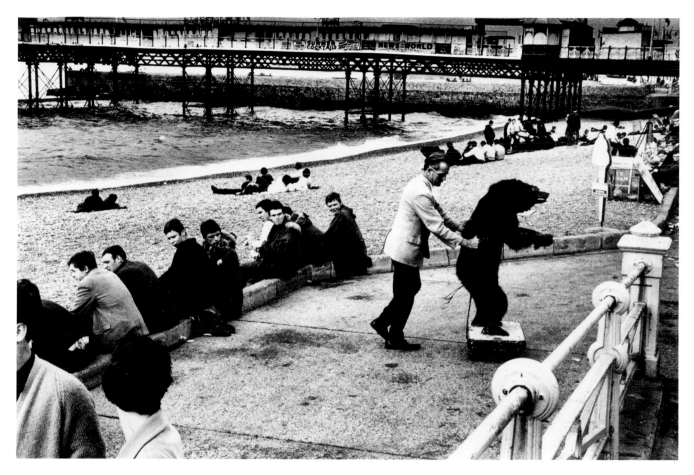

Tony Ray-Jones, mods and entertainer, 1969, silver print, *image 175 x 261mm*

photographic scene, with its parochial tendencies, the lessons he had learned in the USA during a long sojourn as a student in 1961 65. The liberating influence of art director and teacher Alexey Brodovitch, and the lyrical, independent spirit and powerful visual instincts of photographer Robert Frank were effectively absorbed by Ray-Jones. Paul Strand was later to acknowledge in his photographs 'that rather rare concurrence when an artist clearly attaining mastery of his medium, also develops a remarkable way of looking at the life around him, with warmth and understanding. His vision of people as they live in the neighbouring worlds of reality, is comprehensive and complex.... [His photographs] show a remarkable formal organization, the consistent ability of the photographer to seize images constantly in change and movement, in which however everything he includes in the picture is related and unified as a true work of art must be.'[8] Ray-Jones formed the ambition to explore and illustrate the customs and spirit of the British at leisure. His project involved trips to Brighton between 1966 and 1969 that generated memorable, touching and resonant pictures.

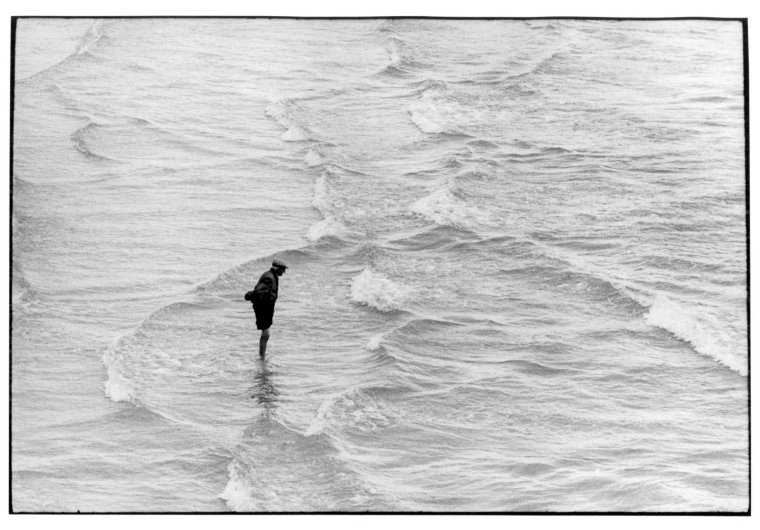

Elliot Erwitt, figure in the sea, 1968, silver print, *image 205 x 305mm*

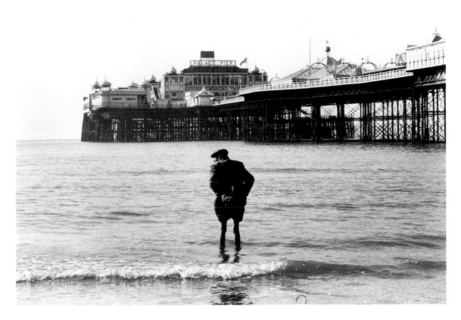

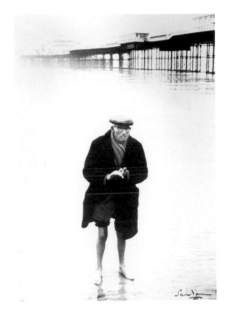

Tony Ray-Jones, figure in the sea, 1967, silver print, *image 177 x 267mm*

Lord Snowdon, figure in the sea, 1966, silver print, *286 x 200mm*

One of Ray-Jones's best-known images shows a lone figure of a man, trousers rolled up, standing in shallow water looking out to the horizon with the Palace Pier to his right. The man, a certain Mr Philips, would stand regularly in this spot, and attracted the attentions of at least two other photographers. Lord Snowdon, a versatile photographer who, as Tony Armstrong-Jones, had developed a committed, informal reportage approach in the fifties, photographed him in the context of a photo-story on loneliness for *The Sunday Times*[9] in 1966. American Elliot Erwitt depicted the man as a tiny, bird-like creature perched in a frame-filling pattern of shallow waves.

In Britain at this time, with very rare exceptions, photography was taught as a craft, a purely technical skill, not as a creative medium. One such exception was Dermot Goulding, assistant in the Royal College of Art photography department. Steve Hiett, a graphic design student at Brighton College of Art between 1958 and 1961,

recalls the influence of Goulding's Friday visits during which he introduced the students to the work of Robert Frank and William Klein, and to the dynamics of foreign, picture-led magazines such as *Paris Match* and *Twen*. Hiett's final examination project was photo-based, a survey of the Carlton Hill district.[10]

Public perceptions of the status of photography were shifting. 'Colour supplement' culture gave the medium glamorous credentials for an energetic, ambitious and socially mobile younger generation. Michelangelo Antonioni's film 'Blow Up' proposed superficially seductive aspects to the life of the photographer. The film was shown in Brighton on its release in 1967. One cinema enthusiast deeply impressed by the multiple layers of the film was the son of our couple who had been photographed on the promenade just after the war. He was now eighteen. He had been drawn to photographs from an early age and since at least 1962 collected them avidly in the form of magazine or newspaper cuttings.

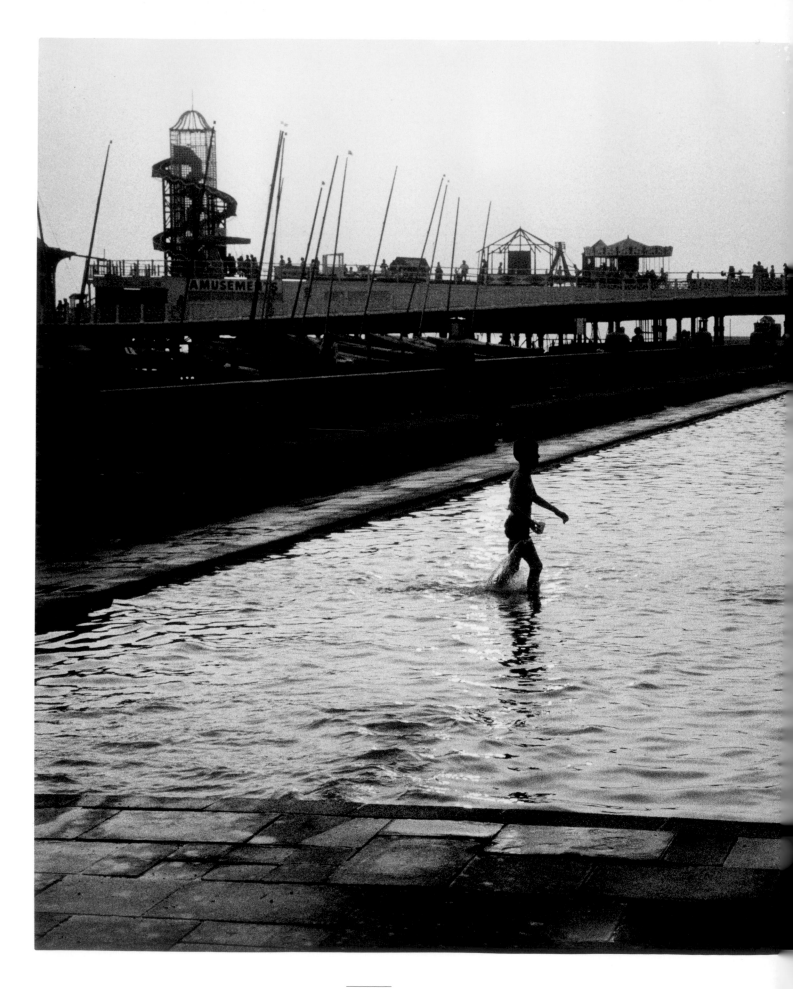

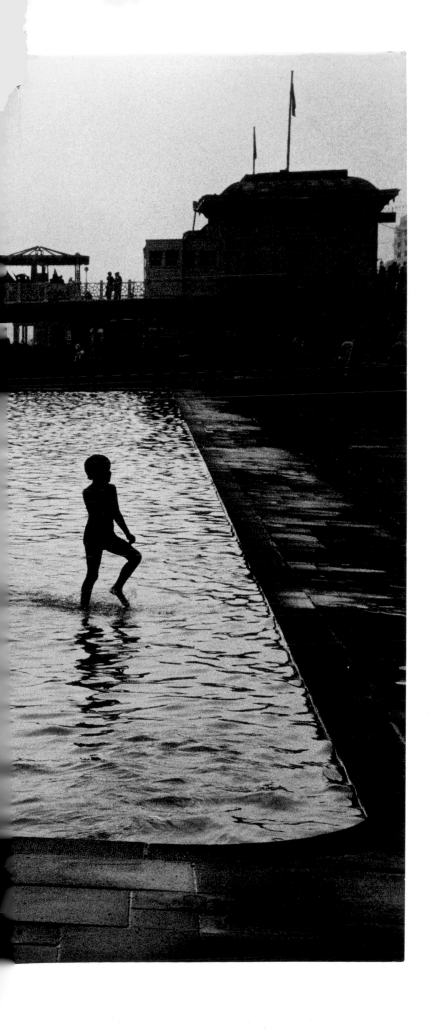

Milford Sanders, boys in paddling pool, 1960s,
silver print, *305 x 404mm*

In the late sixties, he established a friendship that was to prove significant in sharpening his appreciation of photography. This friend was Simon Kentish, a graphic design student at Brighton Polytechnic, as the College of Art was now called. He, like Hiett before him, found within the course an exciting conduit to the expressive and dynamic strengths of great international photography.

In his foundation year, Kentish studied photography with Laurence Cutting, a teacher who, as a student at Brighton alongside Hiett, had also been inspired by Goulding. Cutting returned to Brighton after graduating from the Royal College of Art in 1965, and for a few years fulfilled the role played previously by Goulding. He shared his enthusiasms with the students in the foundation and printmaking courses. 'I had a strong feeling for Roger Mayne and Nigel Henderson,' he recalls, and 'fell in love with Walker Evans and the Farm Security project work.'[11] 'Photography was in the air,' explains Harvey Daniels, who led the printmaking course at that time.[12] Creative photography was not yet on the curriculum, however, as a course that stood on its own. 'Brighton A portfolio of photographs by Jim Arnould' was exhibited in December 1971. A catalogue was published by the Brighton Polytechnic in conjunction with the Arts Council. The introductory notes explain that Arnould, typically, 'is one of a new generation who have developed through advertising and graphics'. Kentish meanwhile was teaching our

young man the practical basics of photography as well as helping sharpen his eye. This grounding was to be put to good use as our young man started to undertake a very particular project involving photography and the town of Brighton.

1. 'Brighton: the home of the English seaside', *Lilliput*, September 1945, pp. 239–46

2. Manuscript caption on verso

3. Quoted: 'Thurston Hopkins man of the streets', *Amateur Photographer*, 18 May 1977, p. 130

4. Letter from Thurston Hopkins to the author, 17 October 1992

5. Mark Boxer, 'British Photography 1955-1965: my part in its downfall', *British Photography 1955-1965: The master craftsmen in print*, The Photographers' Gallery, London, 1983, p. 9

6. H.T. Cadbury Brown, 'An Exhibition of Photographs by Alan Irvine', *Architectural Association Journal*, February 1958, pp. 166–69

7. 'On the Beach – Some Reflections on Holiday Photography by the Famous Candid Photographer – Roger Mayne', *Amateur Photographer*, 17 August 1960, pp. 245–47

8. Quoted: *A day off – an English journal by Tony Ray-Jones*, London, 1974, p. 11

9. Francis Wyndham and Lord Snowdon, 'Loneliness', *The Sunday Times Magazine*, 18 December 1966, pp. 14–21

10. See: Philippe Garner, 'Steve Hiett – In and Out of Fashion', *Fashion Images de Mode*, Gottingen, 1999, pp. 34–45

11. Conversation with the author, 20 June 2002

12. Conversation with the author, 16 June 2002

Laurence Cutting, still life, Whitehawk allotment, 1960, silver print, *385 x 305mm*

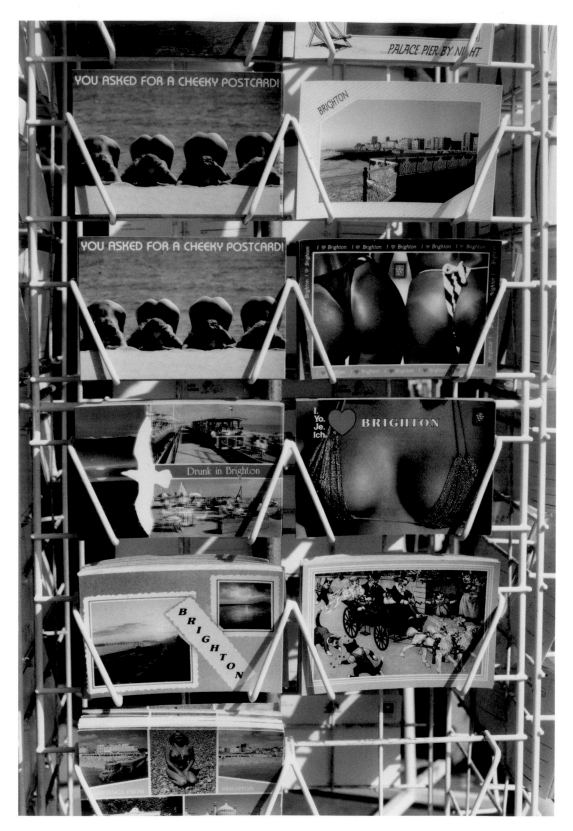

Philippe Garner, postcard rack, September 1989, silver print, *image 560 x 465mm*

COLLECTING AND CONNECTING

It is at this stage in the narrative that the author should perhaps step forward from behind the curtain of his third-person discretion. For, of course, he, that is to say, I am both narrator and player in this tale. My earliest recollection, aged three, is of witnessing the contents of my home being packed into boxes, my seemingly secure environment being dismantled and removed. I watched as my parents set about the practicalities of our move from the flat in Ship Street to the larger flat off the Ditchling Road. Furniture, clothes, and all kinds of domestic items were being taken downstairs to the waiting vehicle. As were toys, and other treasures, and of course the photographs that depicted my father's Sussex childhood, my mother's French family, their meeting and marriage in Aix-en-Provence, and their first years together in Brighton.

Photographs have always had a powerful hold over my imagination. They have informed, educated, intrigued and comforted me. As a teenager, it was through published photographs that I widened my knowledge of the world, and acquired the visual references to appreciate so many aspects of the arts, of fashion, design, architecture and history – of culture in its widest sense. Photographs extended my horizons, stimulated and fed my curiosity. Yet, passionate as I was about photographs, I knew little of the history of the medium.

Graduating in French and Latin from Bedford College, University of London, in 1970, I joined the training scheme run by Sotheby's, the auctioneers. The following summer, already involved in twentieth-century decorative arts, I was invited to take responsibility for cataloguing and co-ordinating Sotheby's first sale of photographs. So began my education in the history of photography. I became aware of the photograph's qualities as an object as well as its impact as an image. And I learned to appreciate the photographic print or plate for its physical presence, its characteristics of texture and colour, and its indefinable aura as an artefact.

Unknown photographer, St Paul's Church,
West Street, 1854, salt print, *158 x 119mm*
The earliest hitherto recorded image on paper made
in Brighton subsequent to Talbot's 1846 studies

I forget which was the first photograph I bought of Brighton. I acquired one print, then another, then more, finding a curious magic in these relics from the past. There was no master plan. But I followed an instinct and realised that I was in a position, at the centre of the market in early photographs, to constitute a unique collection. It would be possible, I realised, to explore the story of photography in Britain, and indeed internationally, by the close investigation of its progress in one town. At the same time, I would be learning the history of my hometown and its people, understanding something of my origins. I tried to locate and acquire as much material as I could, sensing that with time this accumulation would provide an invaluable resource for study. A plot line, a story, or perhaps several stories would emerge from the material that I was bringing together.

Others in Brighton had collected photographs before me. Joseph Ellis's pursuit of the historic Niépce plate provides a vivid account of the powerful passions aroused by the early relics of the medium. Photographs were already being collected in the nineteenth century. In Brighton, this was most typically the pursuit of local antiquarians interested to preserve documents of the changing face of the town. One such was bookseller Charles Hindley, who had an extensive collection of prints, drawings, photographs and printed ephemera relating to the town bound into a copy of John George Bishop's 1880 study, *"A Peep into the Past:" Brighton in the Olden Time, with Glances at the Present*. Extended to a ten-volume set, his assemblage included a portrait of Ellis, the engraving after Claudet's daguerreotype of the Bedford Hotel, and numerous prints by Edward Fox. This set was eventually acquired by another second-hand and antiquarian bookseller, George Holleyman, of Holleyman & Treacher, Duke Street, and preserved till his retirement within his own collection of Brighton documents.

A local bookbinder, James Sharp North, who took over Fox's Market Street premises in the 1890s, acquired

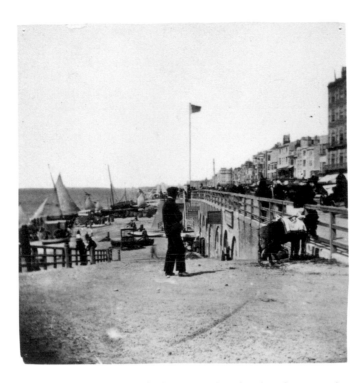

Unknown photographer, looking west along beach and promenade
towards the flag post marking the Battery, dismantled 27 January 1858,
albumen print, *70 x 67mm*

a group of Fox's photographs. He and an associate, Frederick Harrison, were instrumental in arousing interest in the evolution of the town and the surrounding areas. They undertook their own documentary project, gathering their 'Photographic records and survey of Sussex', now in the Brighton Reference Library. Certain of the photographs by Fox and others that North had preserved were acquired after his death by Holleyman who sold them in due course to the principal collector of the next generation, James S. Gray. They had met in 1953 at a talk given by Holleyman to the Brighton & Hove Archaeological Society. A resident of Brighton since 1923, Gray started his collection in 1950, and over the next forty years built an impressive archive, the most comprehensive topographical survey of the town. It is now in the care of the Regency Society.

I befriended Jim Gray after a first visit in the spring of 1974. Over a period of twenty or more years I would visit him regularly to show him what I was acquiring and to learn from his collection and from his prodigious memory.[1] Our approaches were very different. Just as he worked to the well-defined parameters of his topographical interests, so, with the passage of time, I gradually established a framework to my own activity. My project was ultimately about the aesthetics and, above all, the mysteries of the photographic medium. My search involved the exploration of evolving perceptions of the picturesque, but these were always interwoven with a human element, the details of lives lived in the town. It was always as much a story about people as about a place. Aesthetic and human strands were inextricably connected. The collection started to reveal a story of changing times, changing attitudes and changing artistic visions, linked by the common thread of the shared locality. The photograph became identified within my project as a powerful and personal link between people and their past – a tool of memory and of identity. As I pieced together the lives and work of William Constable, George Ruff Senior and Junior, Edward Fox, Thomas

Daniel Meadows, two Brighton girls, summer 1974,
silver print on resin-coated paper, *image 190 x 190mm*

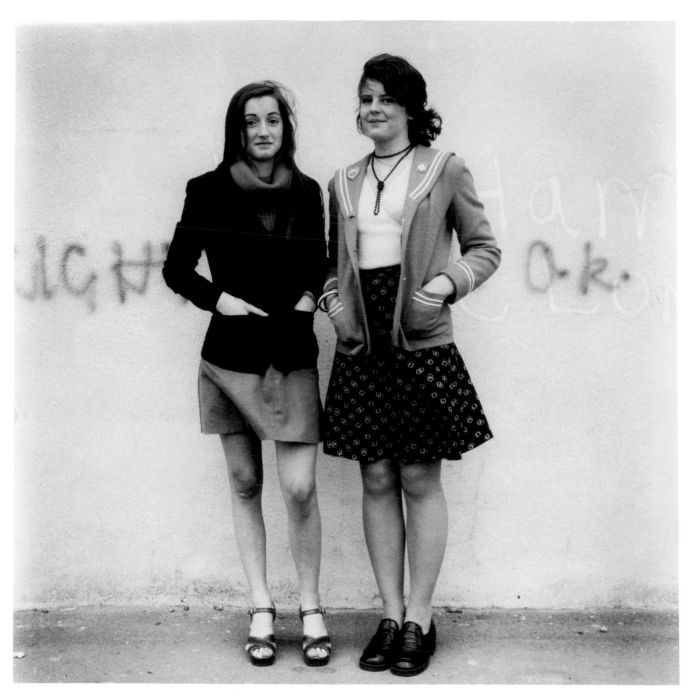

Daniel Meadows, two Brighton girls, summer 1974, silver print on resin-coated paper, *image 191 x 189mm*

Jim Cooke, 'St Peter's church from International Factors', 1993, silver print, *image 306 x 455mm*

Donovan and others, I came to value the connections, the idea of continuity contained within the photographs.

The collection was built over a period of thirty years. Works were acquired from dealers, from auctions, from the photographers themselves or from their heirs, through countless contacts in Brighton, London and elsewhere who were conscious of my singular obsession. Taking stock of the images gathered, I realise that the collection tapers off in the early seventies, at the time I started to collect. Though still a regular visitor to Brighton through the seventies, I was looking back, from the perspective of someone who was now making his life elsewhere. The photograph that opens this narrative, of the young couple walking along the lower

promenade in August 1976, myself with my future wife, marks a key point in the cycle. Only when the time had come to determine a structure for the collection for the purposes of book and exhibition did the full relevance, within my search, of that picture and its companion image of my parents become self-evident.

A few later images help nonetheless to bring the story up to date. The seventies witnessed the slow progress in Britain of a renaissance of interest in photography as a medium with valid artistic credentials. The contributions of the editorial team of *Creative Camera*, and of Sue Davies at The Photographers' Gallery, founded in 1970 in London, are well recorded, as are those of certain Midlands educational institutions, notably Trent

Jim Cooke, '6.03 Victoria – Brighton', 1993, silver print, *image 306 x 455mm*

Polytechnic in Nottingham, and Derby College of Art. When Daniel Meadows, who had studied photography at Manchester Art College, converted a double-decker bus as a home-cum-darkroom and set off in September 1973 to make a photo-portrait of the British people, he included Brighton on his itinerary.[2] He was there in the early summer of 1974 and made a number of pictures of local people, wilfully direct, matter-of-fact images, telling portraits of their time. His was a relatively isolated photographic voice in the town.

In 1981, another graduate, Jim Cooke, came down to Brighton from Sheffield, fired with passion by the teaching of Raymond Moore and other photographers of vision. He took a job in the Photographic Service Unit at the Brighton Polytechnic but recalls a situation of general indifference to the medium as anything other than a technical support service. Over twenty years later, in 1992, the momentum of interest in photography within the graphics and illustration courses was such that a new degree course was set up dedicated to photography as a creative medium. This was under the direction of Karen Norquay, a freelance photographer who had come to Brighton to teach in 1988. Jim Cooke was one of three photographers invited in 1993 to interpret the town within the Brighton Contemporary Photography Commission. The project was sponsored by the Council and supported by The Photographers' Gallery, London, and the University of Brighton, as the Polytechnic had now become. Cooke's images involved layers of

Walker Evans, the Royal Pavilion, 1973, silver print, *image 228 x 254mm*

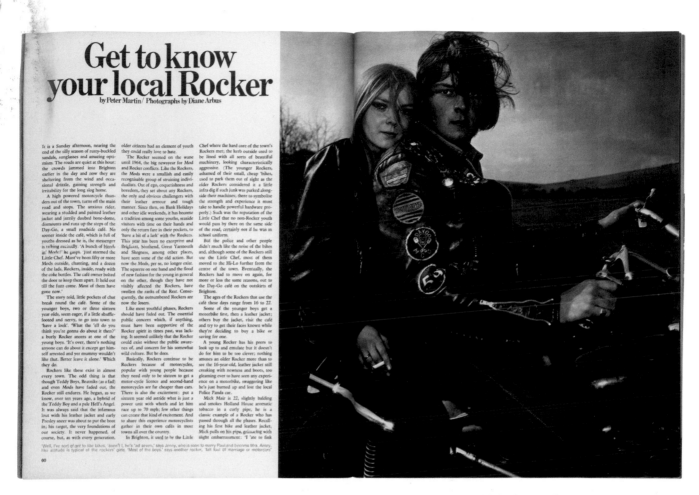

Diane Arbus, spread from the feature 'Get to know your local rocker', *Nova*, published September 1969

metaphor, none more so than his 'St Peter's from International Factors'. Visible in the distance, beyond the glow of the monitors that symbolise a new technology, is the spire of St Peter's, towards which William Henry Fox Talbot had turned his lens in 1846.

Today, Cooke and Mark Power, a student of illustration at the college from 1978 to 1981 who found his medium in photography, play an influential role on the University's course as teachers who are successful practising photographers. The seeds sown by Goulding and Cutting have at last blossomed into a nationally recognised and highly regarded educational programme.

Serendipitous circumstances could, as ever, generate striking and engaging pictures, adding varied threads to the weave of Brighton's photo history. New York photographer Diane Arbus was invited to Britain in the spring of 1969 to make a series of reportages for *Nova* magazine. She made a sombre, powerful sequence of portraits of Brighton's motorbiker community, published as a feature, 'Get to know your local rocker', in the September issue.[3] Another American, Walker Evans, made a visit to Brighton in 1973 and brought a fresh perspective to photographing the Royal Pavilion. In the same year, photographer Ethan A. Russell was given the opportunity to construct a photographic story published as a

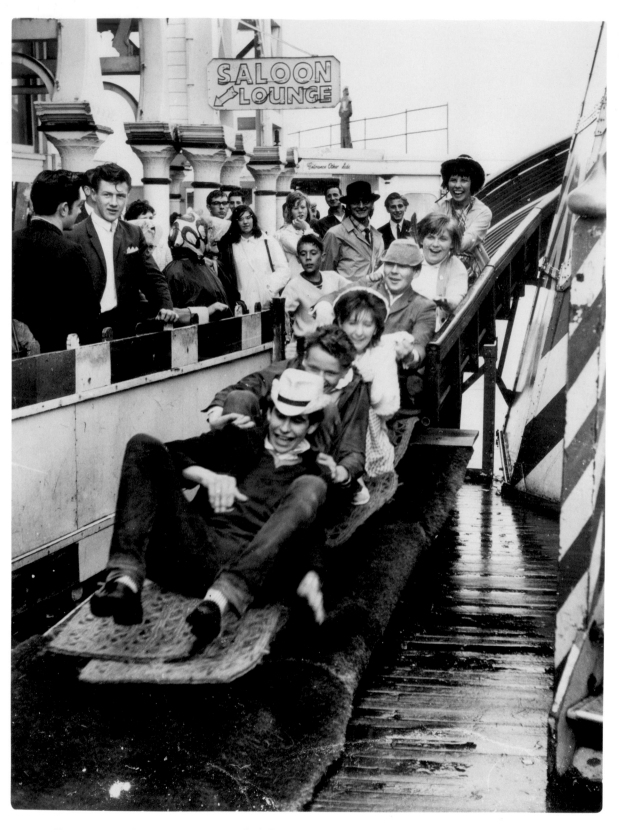

Evening Argus **photographer**, enjoying the helter-skelter on the Palace Pier, date stamped 10 August 1962,
silver print, *202 x 151mm*

Ethan A. Russell, spread from booklet in album sleeve of The Who's 'Quadrophenia', 1973

booklet inserted in the album sleeve of The Who's 'Quadrophenia'. His grainy, reportage-style stagings of a young London Mod's journey to Brighton revisit and give visual consecration to a mythology barely a decade old. Around this time, an anonymous press photographer saw the graphic potential in a Lamb's Navy Rum poster. His image juxtaposes the glamorous Caroline Munro with rectangles of texture and tone and a sign for the Catholic Club entrance. The ingredients of ephemeral posters, typographic signs and the textures and patterns of buildings, proposed as subject matter fifty years before in the images of Deane, Wiles & Miller, have become a part of the stock-in-trade of the medium. Some years later, in 1984, the bombing of the Grand Hotel made front-page grabbing images of another kind.[4] Local photographer Roger Bamber has consistently supplied memorable pictures to the national press, principally *The Guardian*. His 1991 study of a dense crowd of young people enjoying the sun on the beach promenade outside the Shark Bar continues a long tradition of recording the specifics, the clothes and body language of people enjoying the town.

Cleland Rimmer, study of the Grand Hotel, 'Bombed', published on the front page of the *Evening Argus*, 12 October 1984, *420 x 319mm*

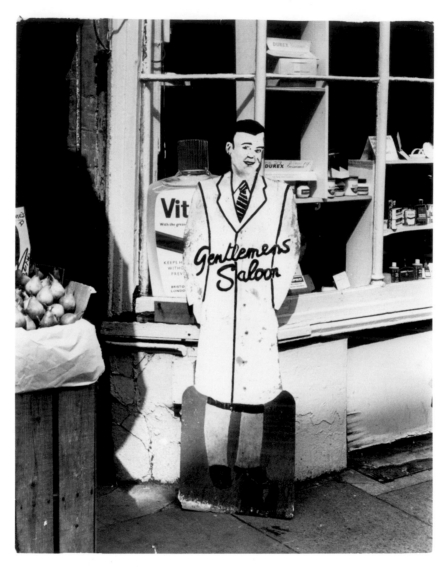

Chris Ware for Keystone, barber's saloon, George Street, Kemp Town,
3 August 1967, silver print, 259 x 203mm

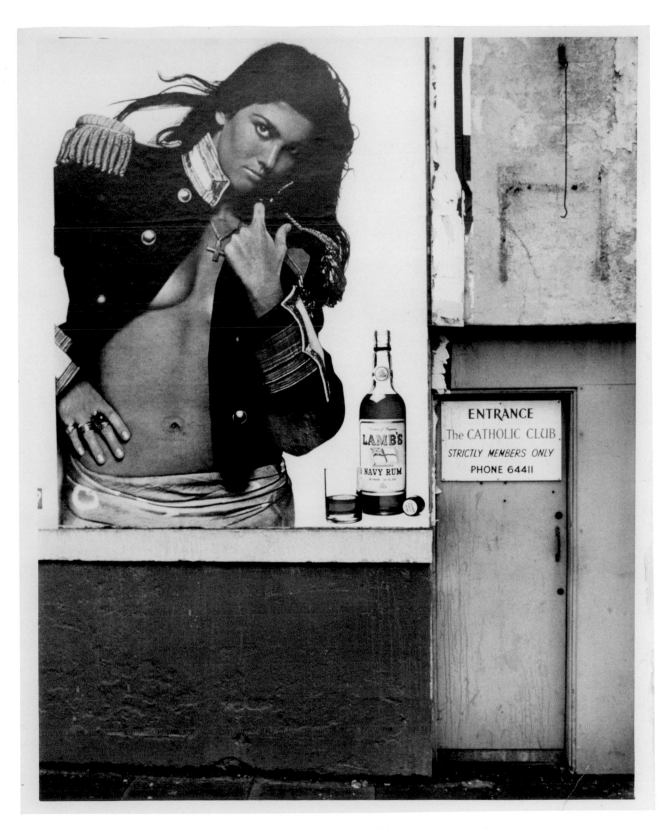

Unknown freelance photographer for Keystone, Christian Club entrance with Lamb's Navy Rum poster,
17 January 1972, silver print, *257 x 202mm*

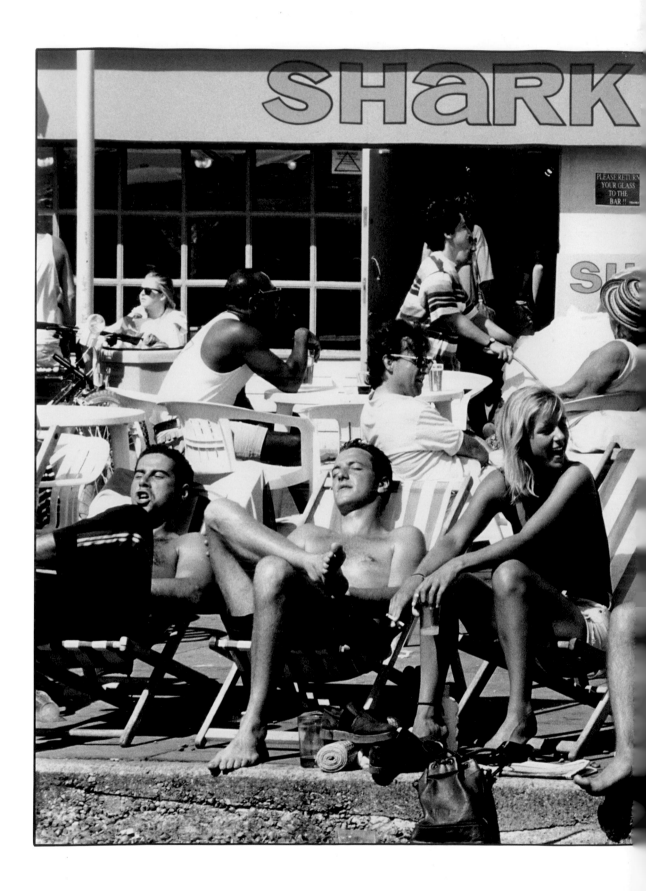

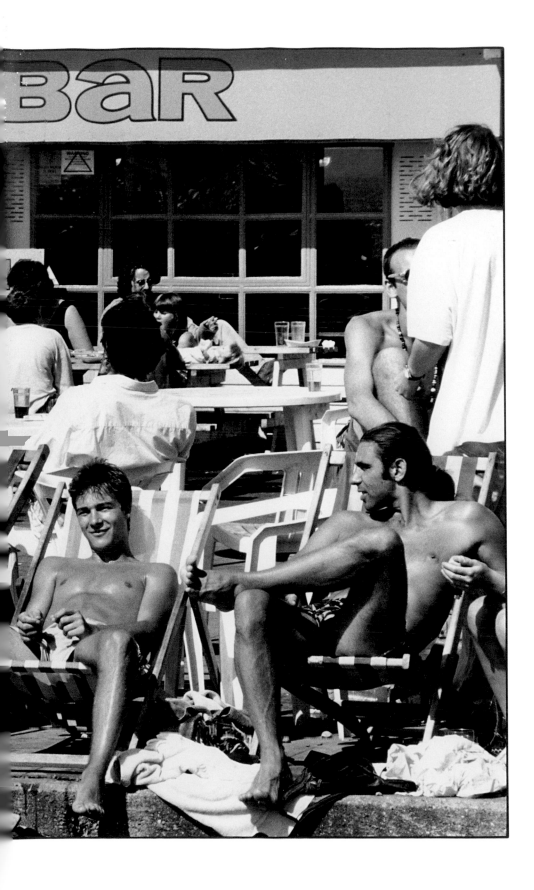

Roger Bamber, Shark Bar, 1991,
silver print, *image 205 x 301mm*

Philippe Garner, on the Palace Pier, looking east, 19 December 1994, around 3.00–3.30pm, silver print, *image 465 x 560mm*

It has, finally, proved irresistible to the author to explore for himself the path followed by those generations of photographers whose legacy he has investigated so systematically. He has endeavoured to fix a few of his own impressions on film, wanting to make and leave his own traces within this seaside album – a long-flowing story of images and ambitions, photographs and memories.

Philippe Garner
London, June 2002

1. James S. Gray published two key reference works: *Victorian and Edwardian Brighton from old photographs*, London, 1972; and *Brighton Between the Wars*, London, 1976

2. A selection of his images was published: Daniel Meadows, *Living Like This*, London, 1975

3. Peter Martin, 'Get to know your local rocker', *Nova*, September 1969, pp. 60–65

4. 'Bombed', *Evening Argus*, 12 October 1984, front page photograph by Cleland Rimmer

Philippe Garner, on the Palace Pier, 28 August 1995, 11.20am, silver print, *image 465 x 560mm*

Philippe Garner, beach vista, September 1994, 3.45pm, silver print, *image 465 x 560mm*

Overleaf: **Philippe Garner**, view of the town in the rain from the Palace Pier,
23 December 1995, around 2.45–2.50pm, silver print, *image 465 x 560mm*

ACKNOWLEDGEMENTS

I wish to express my heartfelt gratitude to the many people who have helped me bring my project to fruition. Their efforts, support, generosity and faith have helped me piece together this story and turn it into a book and exhibition. They include:

Pierre Apraxine, Michel Auer, Roger Bamber, Dorothy Bohm, Clarissa Bruce, John Buck, Tom and Elinor Burnside, Mathew Butson, Henri Cartier-Bresson, Camay Chapman-Cameron, Nicola Coleby, Jim Cooke, Lydia Cresswell-Jones, John Culme, Laurence Cutting, Antony Dale, Harvey Daniels, Sue Davies, Terry Davis, Keith de Lellis, Harry C. Donovan, Stephen Ellinger, Elliot Erwitt, Robin Fletcher, Colin Ford, Eric Franck, George Freston, Stephen Furness, Hilary Gerrish, Arthur Gill, James S. and 'Daisy' Gray, Linda Groves, Helen Grundy, Anthony Hamber, Martin Harrison, Shane Hassett, Mark Haworth-Booth, Bob and Paula Hershkowitz, Steve Hiett, John Hillelson, George Holleyman, Thurston Hopkins, Chris Horlock, Frank Horvat, Bernard Howarth-Loomes, Alan Irvine, Anne Jackson, Kenny Jacobson, Daniel Katz, Simon Kentish, John-Paul Kernot, Hans Kraus, Geoffrey Lintott, John Lord, Nick Lott, Harry Lunn, Ezra Mack, Padraig Madden, Roger Mayne, Daniel Meadows, David Alan Mellor, David Mitchell, Ian and Angela Moor, Robin Muir, Weston Naef, Mechtild Nawiasky, Gwyn Nicholls, Charles Noble, Karen Norquay, Norman Norris, Colin Osman, Graham Ovenden, Brian Page, Colin Page, Richard Pollard, Mark Power, Carla Preston, Bob Pullen, Anna Ray-Jones, Nicola Redway, Michael Rich, Howard Ricketts, Dorothy Ruff, Jessica Rutherford, Sean Sexton, Larry Schaaf, Jim Shiels, David Simkin, Jennifer Smith, Lord Snowdon, Jennifer Southwell, Erich Sommer, Pierre Spake, Fred Spira, Alec Sterling, Roger Taylor, Sean Thakrey, Pete Turner, Norman Turpin, Caroline Venables, Beryl Vosburgh, Tony Waddingham, Sam Wagstaff, Harold and Edith White, Philip Wilson and Bob Wiskin.

Special thanks to my parents Albert and Angèle Garner, my sister Noëlle and her husband Joe Paxton, my aunt Marjorie Kipps, my ever patient, insightful and supportive wife Lucilla, and our son Dominic.

First published in 2003 by
Philip Wilson Publishers,
7 Deane House,
27 Greenwood Place,
London NW5 1LB

in association with

The Royal Pavilion, Libraries & Museums, Brighton & Hove

on the occasion of the exhibition
A Seaside Album: Photographs and Memory
held at Brighton Museum & Art Gallery, 10 May to 8 October 2003

Distributed throughout the world (excluding North America) by
I.B. Tauris & Co. Ltd,
6 Salem Road,
London W2 4BU

Distributed in North America by
Palgrave Macmillan, a division of
St. Martin's Press,
175 Fifth Avenue,
New York, NY 10010

ISBN: 0 85667 560 1 (hardback edition)
ISBN: 0 85667 561 X (paperback edition)

Exhibition curated by Philippe Garner
Exhibition organised by Helen Grundy, Exhibitions Officer, supported
by Nicola Coleby, Senior Exhibitions Officer, Royal Pavilion, Libraries
& Museums, Brighton & Hove

Designed by Tony Waddingham, oblique@pandora.be
Printed and bound by EBS-Editoriale Bortolazzi-Stei
San Giovanni Lupatoto (VR) - Italy